IMAGES
of America

CLEVELAND'S
UNIVERSITY CIRCLE

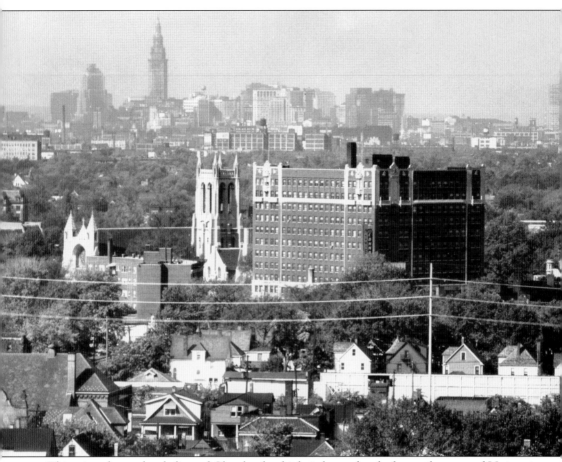

This view shows the skyline of Cleveland, which is located only four miles west of University Circle. This proximity makes University Circle a popular and easily accessible destination for visitors and inhabitants of Cleveland. The tall building is the Terminal Tower, which was built in 1929 and now houses Tower City Center Shopping District and the hub for the Greater Cleveland Regional Transit Authority (RTA). (Cleveland Press Collection, CSU.)

On the cover: Society ladies from the Garden Center of Greater Cleveland plant flowers in Wade Park near the Cleveland Museum of Art in the 1930s. The garden center is now part of the Cleveland Botanical Garden. (Cleveland Press Collection, CSU.)

IMAGES
of America

CLEVELAND'S
UNIVERSITY CIRCLE

Wayne Kehoe

ARCADIA
PUBLISHING

Published by Arcadia Publishing
Charleston SC, Chicago IL, Portsmouth NH, San Francisco CA

Printed in the United States of America

Library of Congress Catalog Card Number: 2007921472

For all general information contact Arcadia Publishing at:
Telephone 843-853-2070
Fax 843-853-0044
E-mail sales@arcadiapublishing.com
For customer service and orders:
Toll-Free 1-888-313-2665

Visit us on the Internet at www.arcadiapublishing.com

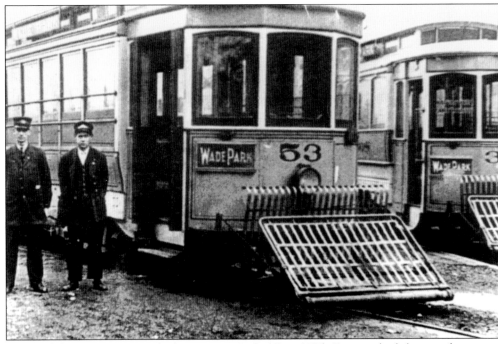

The Euclid Avenue streetcar had its turnaround at East 107th Street, which became known as the University Circle stop. Euclid Avenue was known as Millionaire's Row because of the high concentration of wealthy inhabitants and their mansions. Today there are only three mansions left of that era. (Cleveland Press Collection, CSU.)

CONTENTS

ACKNOWLEDGMENTS

I would like to take a moment and say a big and gracious thanks to some people who really helped me with this wonderful project.

First I would like to thank Lynn Duchez Bycko of the Cleveland State University (CSU) Special Collections. Her knowledge and insight were invaluable to me. I also want to thank the *Cleveland Press*. Although you are no more, your rich wealth of pictures that you donated keeps the *Cleveland Press* alive.

I would also like to thank Melissa Basilone, my editor at Arcadia Publishing. An author could not have asked for a nicer and more helpful editor for their first published work.

More thanks are given to my friends and shipmates onboard the Steamship William G. Mather Museum, Arcadia authors, Thomas G. Matowitz, and Mathew L. Grabski. I hope you both continue to find success in your writing. Robert Vance also offered interesting facts and insight into the history of University Circle. Thanks for all of your suggestions and encouragement in this process.

Finally, I would like to thank my family for their belief in my ability to do this book. My wife, Katy; my sister, Terri; my brother, Dale; and my mother, Roseanne, all offered their prayers and hopes for my success.

I would like to dedicate this book to my late father, John (Jack) Kehoe, and my late grandmother, Rita Vozar. They both taught me to love and respect history. I'll sign a copy for each of you!

INTRODUCTION

During the Revolutionary War, some Connecticut inhabitants had their lands and farms burned by the British. After the war, the new government of the United States promised land for settlement by Connecticut in the Northwest Territory, including Ohio. It became known as the Connecticut Land Company. In 1797, Moses Cleveland led a surveying party to where the Cuyahoga River enters Lake Erie, and the city of Cleveland was born.

Nathaniel Doan, a member of the second surveying party, arrived in Cleveland shortly after its founding. Doan decided to pack up his wife and eight children and moved to a wooded area four miles to the east of downtown. He built a hotel and tavern at Doan's Corners, which became a popular stop for travelers from Buffalo. Cleveland quickly grew into an industrial and financial giant that rivaled Chicago.

Doan's Corners began to take shape from the efforts of Cleveland's leading citizens. In 1882, Western Union Telegraph Company founder Jeptha H. Wade donated 75 acres for a public park and an art gallery. In the same year, railroad tycoon Amasa Stone donated $500,000 and 43 acres of land to make it possible for Western Reserve University to relocate to Cleveland from rural Hudson. In 1885, Case School of Applied Science moved from downtown to Doan's Corners. A streetcar line was built on Euclid Avenue, or Millionaire's Row, as it was called. The streetcar ran to East 107th Street and made its turnaround, giving the area the name University Circle.

University Circle would have looked very different today if it was not for the generous contributions of time, money, and resources from some of Cleveland's leading citizens. The richest and most famous of these was John D. Rockefeller. It was Rockefeller's purpose in life to make as much money as possible and then use it wisely to benefit mankind. In 1870, Rockefeller helped form the Standard Oil Company, which would become the most profitable company in the world. His 50-room summer estate was located on the border of University Circle and East Cleveland. On the country's centennial in 1876, Rockefeller gave land to the city to be used as a park. The park now bears his name and connects University Circle to Lake Erie. He also gave the city money to construct stone bridges over the Doan Brook. Rockefeller is a study of contradictions. He showed no mercy and crushed competitors who stood in his path for profit. Yet he was deeply religious and gave millions to organizations all over the country.

Another important figure in the development of University Circle is Jeptha Wade. Wade was the president of the Western Union Telegraph Company. Along with Leonard Case, Wade was instrumental in the founding of the Case Institute of Applied Science in 1880. In 1881, Wade gave Cleveland 75 acres of land near East 107th Street and Euclid Avenue. The generosity of the Wade family continued through his son, Randall, and his grandson, Jeptha Wade II. Their donation made possible the Cleveland Museum of Art, Severance Hall, and Wade Park.

Today University Circle Inc. (UCI) is the governing body of the area. UCI promotes the institutions and plans the events that the circle is famous for. Whether a student, a visitor, or an inhabitant, University Circle is an amazing place to explore.

Enjoy *Cleveland's University Circle*!

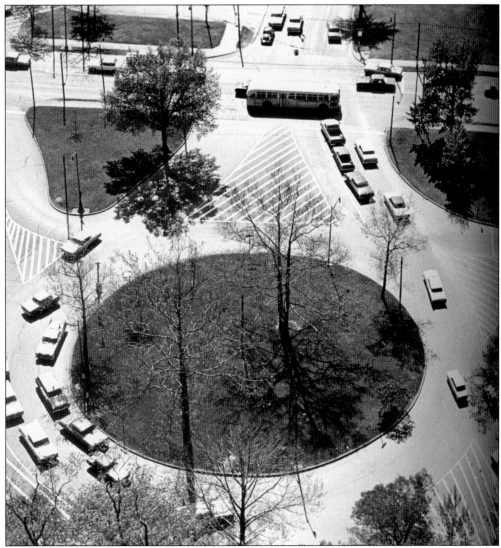

The circle is still in use for traffic. Today buses have replaced the streetcar for public transportation in Cleveland. The last streetcar ran in 1954. The Greater Cleveland Regional Transit Authority (RTA) is in the midst of building the multimillion-dollar project that will be known as the Euclid Corridor Project, which will connect downtown Cleveland to University Circle using environmentally friendly electric trolleys. (Cleveland Press Collection, CSU.)

One

INSTITUTIONS OF HIGHER LEARNING

As the name applies, University Circle is home to several institutions of higher learning, including Case Western Reserve University, Cleveland Institute of Art, and Cleveland Institute of Music. University Circle is also home to the Cleveland Music School Settlement, Gestalt Institute of Cleveland, and the Ohio College of Podiatric Medicine.

Case Western Reserve University (CWRU) was created by the merging of Western Reserve University and Case School of Applied Science in 1967. Today CWRU enrolls some 10,000 students from every state and 80 countries. CWRU is one of the nation's leading independent research universities. It ranks second behind only Ohio State University in the size of its endowment.

Cleveland Institute of Art (CIA) began as the Western Reserve School of Design for Women in 1882. CIA is coeducational now and offers a five-year bachelor of fine arts degree. CIA also extends programming to the public through gallery exhibitions, children's classes, and visiting artist lectures.

Cleveland Institute of Music (CIM) is a nationally recognized conservatory founded in 1920. CIM operates two divisions: the collegiate conservatory, offering bachelors and master's degrees, professional studies, artist diplomas, and doctor of musical arts degrees; and the preparatory department for younger students and adults.

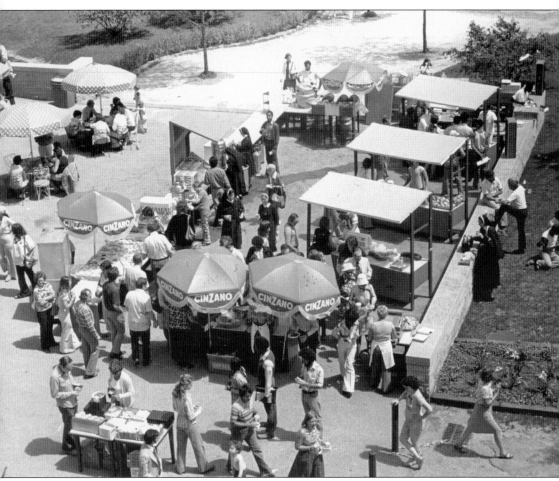

This was a warm and sunny spring day on the CWRU campus. (Cleveland Press Collection, CSU.)

The Old President's House on the campus of what was Western Reserve College (WRC) is pictured here. The college was founded in the town of Hudson, 26 miles southeast of Cleveland, in 1826. David Hudson gave money to the school so that it would be located in his namesake town. (Cleveland Press Collection, CSU.)

The campus chapel was built in 1836. WRC was located in Hudson rather than Cleveland because the founders believed that students could not learn in an environment with sailors, women, and distractions that Cleveland offered at the time. The chapel is now part of Western Reserve Academy, a very prestigious preparatory school. (Cleveland Press Collection, CSU.)

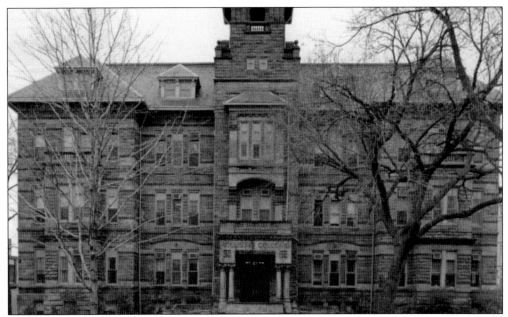

By the 1880s, it became evident that WRC would have to move to a larger city if it wanted to continue as a college. Amasa Stone (1818–1883), a wealthy industrialist, agreed to give the college much-needed funding if it agreed to two provisions. One, he wanted WRC to move to Cleveland, and the second, he wanted its name changed to Adelbert College to honor his son who had drowned while a student at Yale. Adelbert became the undergraduate college for men, and WRC became Western Reserve University (WRU). (Cleveland Press Collection, CSU.)

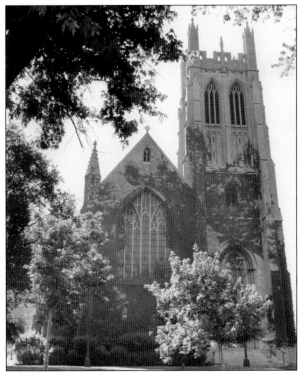

Amasa Stone Church sits on the campus of CWRU. Stone had many terrible things that occurred to him and his family. His son, Adelbert, drowned in the Connecticut River while he was a student at Yale in 1865. Then on December 29, 1876, a bridge carrying a train over the Ashtabula Gorge collapsed and killed over 100 people. He never got over the two tragedies, and on May 11, 1883, he committed suicide. (Cleveland Press Collection, CSU.)

12

This is a 1930 photograph of Flora Stone Mather College for Women. Flora Stone Mather gave money for everything from books to boots. She visited the campus regularly and knew all the girls. Every year, she would invite the senior class to her mansion on Euclid Avenue for a party. The Mather Mansion of 1910 is one of the three that are still standing. It is part of CSU. (Cleveland Press Collection, CSU.)

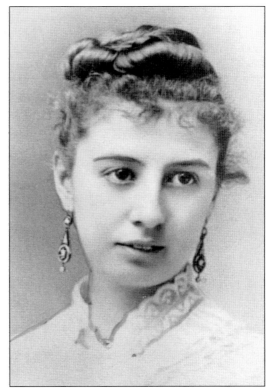

Flora Stone Mather (1852–1909) was the youngest daughter of Amasa Stone. She graduated with honors from Cleveland Academy and then married Samuel Mather in 1881. In her will, she had bequests to over 30 religious, educational, and charitable organizations. (Cleveland Press Collection, CSU.)

Samuel Mather (1851–1931) was cofounder of Pickands Mather and Company, which was allied with the steel industry. The company leased mines and had a fleet of freighters on the Great Lakes. During World War I, Mather organized the war chest, which donated $750,000 to the war effort. Mather received the cross of the Legion of Honor from the French government. When he died, he was the richest man in Ohio; John D. Rockefeller had already moved out of Cleveland by then. (Cleveland Press Collection, CSU.)

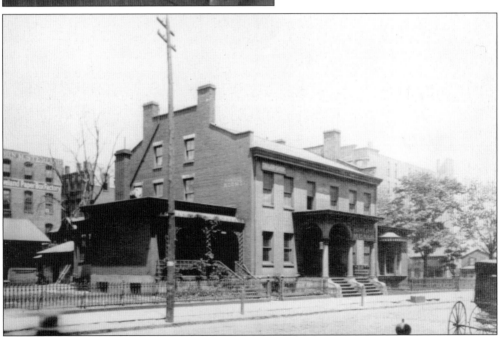

The Leonard Case house was on Rockwell Avenue near Public Square in downtown Cleveland. Case's house was the first building of the new Case School of Applied Science, which opened in 1881. In 1885, Case School of Applied Science moved to University Circle to be closer to WRU. This photograph dates from 1890. (Cleveland Press Collection, CSU.)

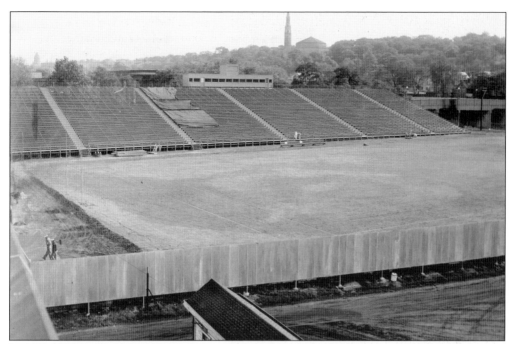

In 1951, WRU's Clarke Field hosted Kent State in the first football game to be played on campus. The seating for 8,500 was used for the National Air Races. The fence marks the boundary between WRU and the renamed Case Institute of Technology. (Cleveland Press Collection, CSU.)

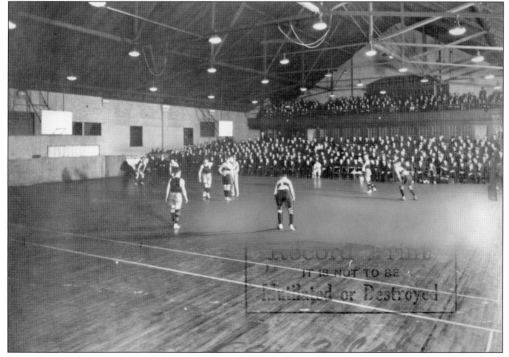

This is a 1919 view of the Adelbert Gym. CWRU offers 19 varsity athletic teams. (Cleveland Press Collection, CSU.)

Although college can seem like prison and, in this photograph, look like one, this is actually a photograph of a new dormitory that was built in 1947. Nearly 80 percent of students live on the campus of CWRU. The snoring must be horrendous. (Cleveland Press Collection, CSU.)

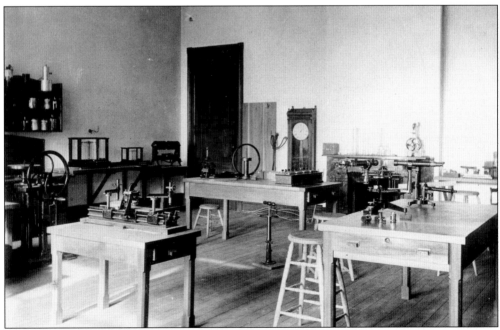

This photograph shows a physics laboratory from the 1880s at Case Institute of Technology. It looks a lot like the physics laboratory that is still in use by students over 100 years later. Case Institute of Technology has always been a leader in the sciences and technologies. (Cleveland Press Collection, CSU.)

This is the 1952 student lounge at Case Institute of Technology. Case admitted female students very early in its history, especially during World War II. (Cleveland Press Collection, CSU.)

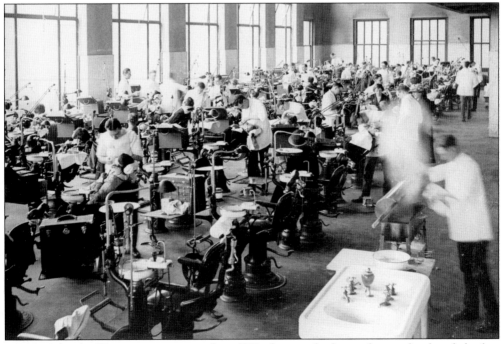

WRU's School of Dentistry was started in 1892 along with the graduate school and the law school. Here is a 1927 view of dentists hard at work. One can almost hear the drills. (Cleveland Press Collection, CSU.)

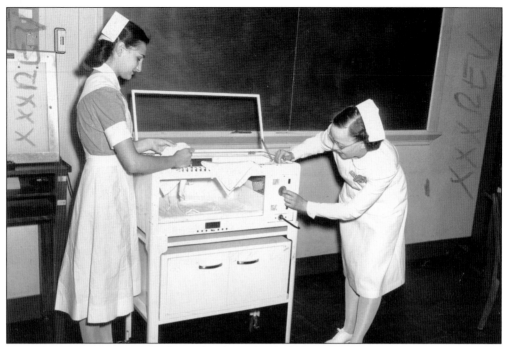

Two nurses inspect a new incubator for the School of Nursing at WRU in 1948. CWRU has a wonderful working relationship with two great health care centers, University Hospitals of Cleveland and the Cleveland Clinic. (Cleveland Press Collection, CSU.)

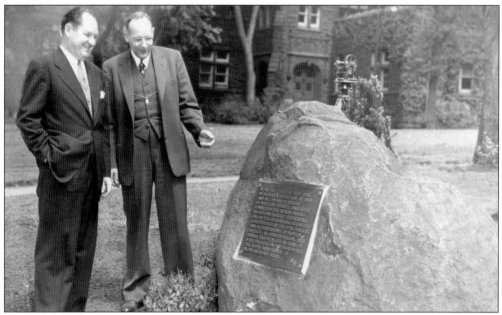

Pres. Thomas Keith Glennan (left) of Case Institute of Technology and Pres. John S. Millis of WRU inspect a new plaque on a rock that the two colleges will share. Both schools were using each other's facilities for years, so the decision was made to unite. As Millis put it, "we had been going steady for about 10 years, we had been sleeping together for about 5 years, and it was about time we got married!" (Cleveland Press Collection, CSU.)

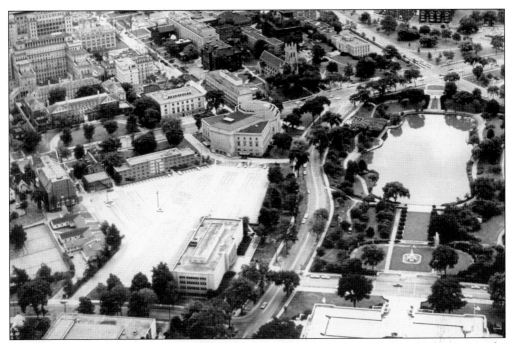

This aerial view shows the campus of CWRU after the merger in 1967. Its 150 acres are right in the midst of the other University Circle attractions. CWRU is the largest private college in Ohio. (Cleveland Press Collection, CSU.)

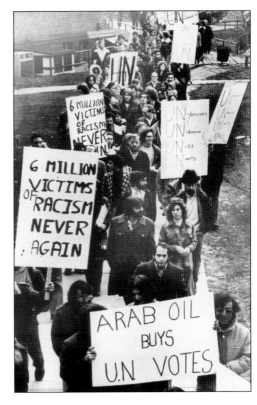

This scene could be a picture of modern times. CWRU was overshadowed by the events at Kent State University, but in the 1960s and 1970s, the campus was very active in social issues and antiwar demonstrations. Here students demonstrate against the United Nations resolution on Zionism in 1975. (Cleveland Press Collection, CSU.)

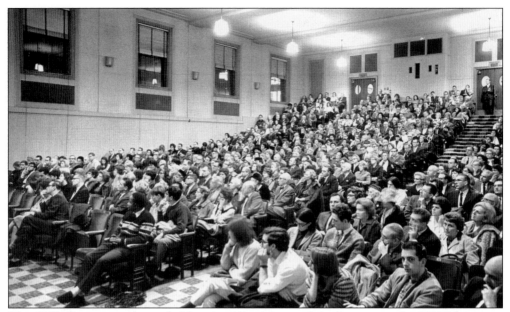

This 1965 alumni meeting was held in the Allen Memorial Auditorium on the CWRU campus. The meeting was held to discuss the future of student protests. The alumni agreed that the student protests served a good purpose, but they could not agree on the students' methods of protest. (Cleveland Press Collection, CSU.)

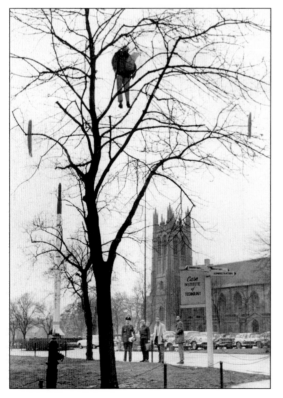

This photograph shows a protest held by the freshman class at CWRU. The dummy of Prof. Malcolm Kenney was hanged in effigy. The students were upset because 88 of their fellow classmates received failing grades in chemistry. Luckily the students did not use the 70-foot-long scout missile in the background that is part of a space exhibit. (Cleveland Press Collection, CSU.)

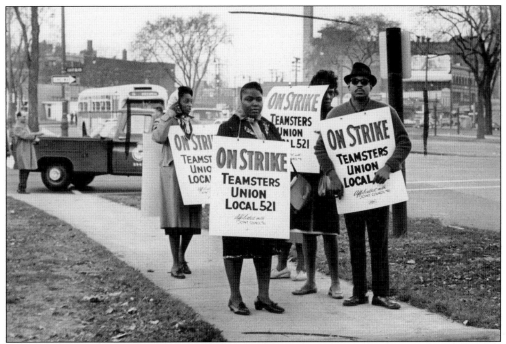

Local 521 of the teamsters goes on strike at CWRU in 1963. The 70 janitors were upset at the university's refusal to recognize the teamsters as their agent. The college said it would handle each employee on an individual basis. (Cleveland Press Collection, CSU.)

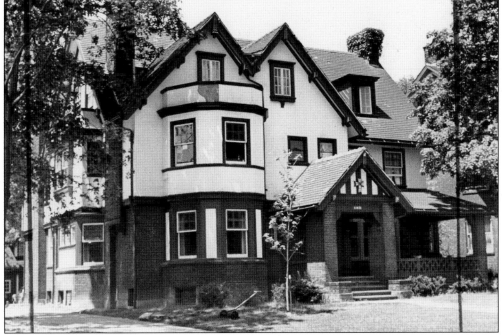

This is the Sigma Chi fraternity house on the CWRU campus. Today CWRU offers its students the opportunity to join 22 fraternities and sororities, 30 percent of which do. (Cleveland Press Collection, CSU.)

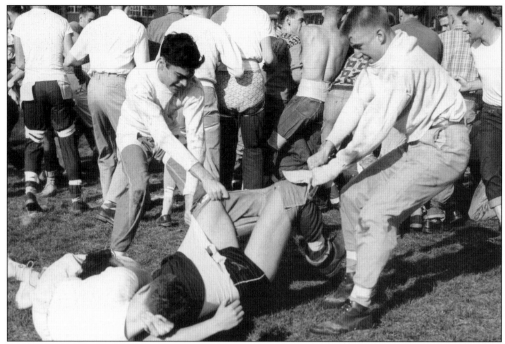

Students participate in the annual sophomore-freshman tug-of-war. After going through this, it is pretty evident why those freshmen were so upset about their chemistry grades. (Cleveland Press Collection, CSU.)

This is the biology building at WRU in 1941. Biology was one of the disciplines that helped shape the future joining of the two institutions. Case Institute of Technology students were allowed to take biology courses at WRU. (Cleveland Press Collection, CSU.)

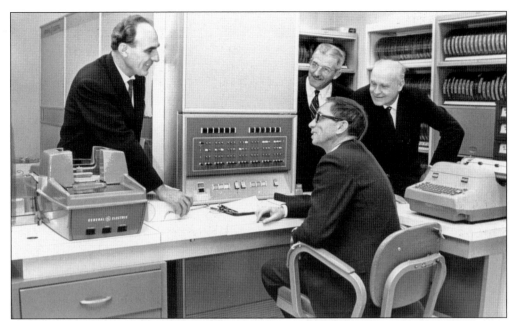

CWRU professor A. J. Goldwyn (seated) and executive director Dr. Phillip Gove (center, standing) play host to visiting Soviets, Nikolai Arulyunov (left), chief of the Soviet Administration of Scientific and Technical Information, and Prof. A. I. Mikhailov, director of the Soviet All-Union Institute of Scientific and Technical Information. This cooperation was during the height of the cold war. (Cleveland Press Collection, CSU.)

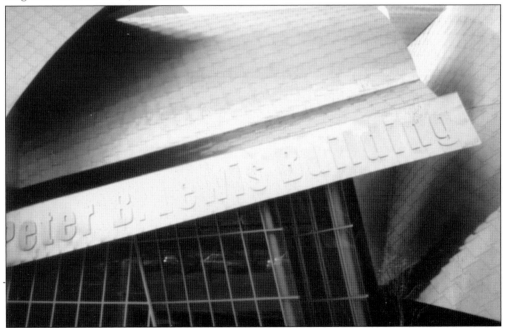

Weatherhead School of Management's Peter B. Lewis Building was designed by world-renowned architect Frank O. Gehhry and is the newest addition to the CWRU campus. The building is named after the owner of Progressive Insurance. CWRU's campus is full of both historic and modern structures, much like Cleveland itself. (Photograph by the author.)

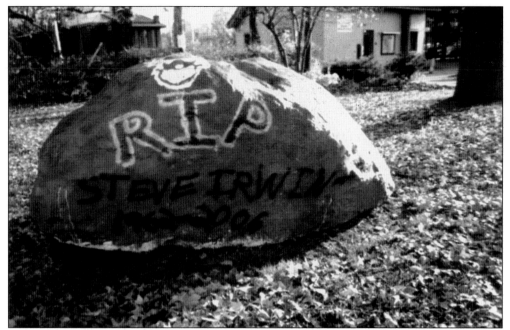

Students show their respect for animal rights activist and television host Steve Irwin. He will be missed. (Photograph by the author.)

The Cleveland Institute of Art (CIA) began in 1882 as the Western Reserve School of Design for Women. The present building (built in 1955–1956) cost $2.5 million. The name changed to CIA in 1948. (Cleveland Press Collection, CSU.)

The coursework at CIA can be monstrous. Actually this photograph is from a masque ball at CIA in 1956. Students at CIA can specialize in painting, graphic design, sculpture, and metal. Studio classes are augmented by humanities and social science classes. (Cleveland Press Collection, CSU.)

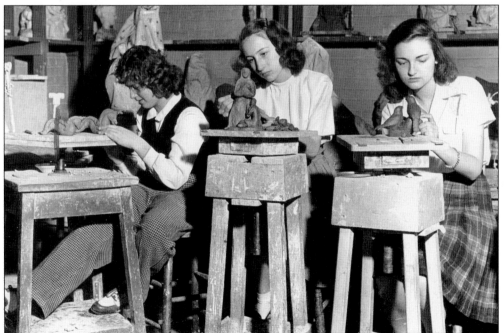

Pictured here is a 1947 pottery class at CIA. CIA played a vital role during the Great Depression and World War II, when mapmaking and medical drawing were added to the curriculum. (Cleveland Press Collection, CSU.)

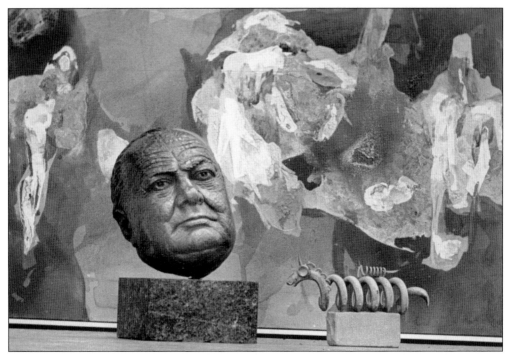

Pictured here is an abstract painting by John Teyral entitled *Deprofundis*. The bust is of Great Britain's prime minister Winston Churchill. (Cleveland Press Collection, CSU.)

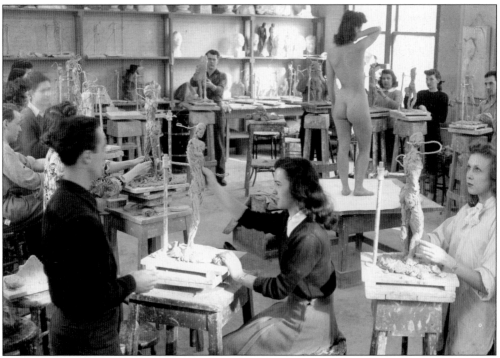

It is a wonder why there are not more art students. This is a sculpture class at CIA in 1957. (Cleveland Press Collection, CSU.)

26

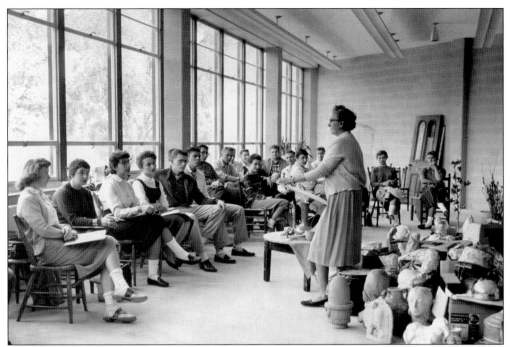

Katherine Cass's freshman watercolor class is pictured here. In 1892, CIA tried to merge with WRU, which was located nearby. Today CIA is a private coeducational institution. (Cleveland Press Collection, CSU.)

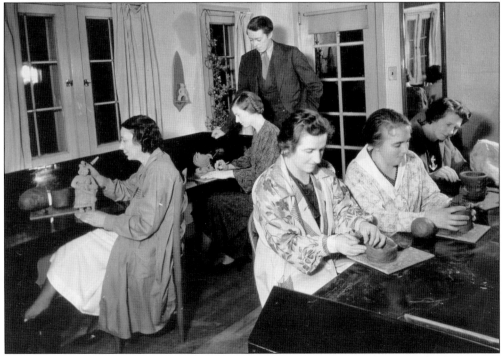

Adult students work on their pottery projects. CIA began offering adult and child classes in 1917, and it continues to do so today. (Cleveland Press Collection, CSU.)

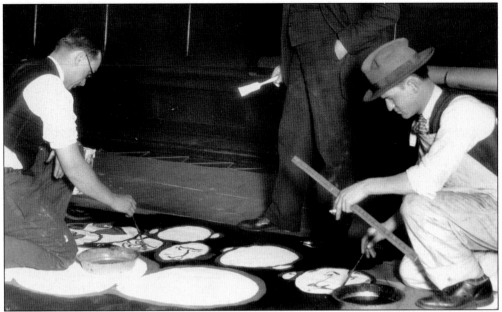

In this photograph, funny faces are painted for a poster to be hung in the ballroom of Danceland for the Kokoon Club's annual meeting of 1928. The club was formed in 1911 by Carl Moellma and William Sommer, who were both artists working for the Ohio Lithograph Company. At its height in the 1920s, the club boasted 60 of Cleveland's finest artistic individuals. (Cleveland Press Collection, CSU.)

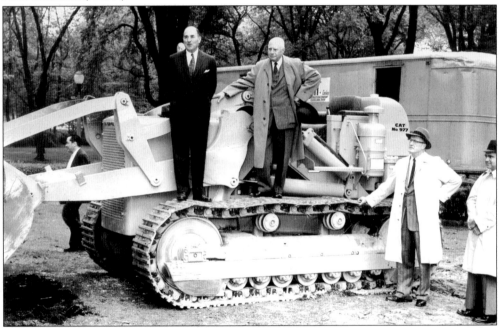

The Cleveland Institute of Music (CIM) was founded in 1920. At one time, classes were held in the Samuel Mather mansion. This groundbreaking in 1960 cost $2.3 million as the school moved to University Circle. CIM director William Treuhaft and University Circle Inc. president Sidney Congdon pose for a picture. (Cleveland Press Collection, CSU.)

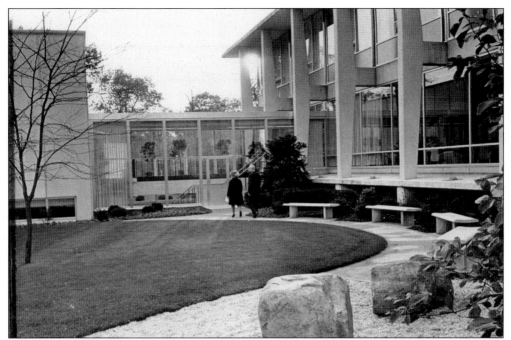

CIM ranks among the top tier of music schools in the United States. Of the 1,700 students that attend CIM, 80 percent perform in major national and international orchestras and opera companies. (Cleveland Press Collection, CSU.)

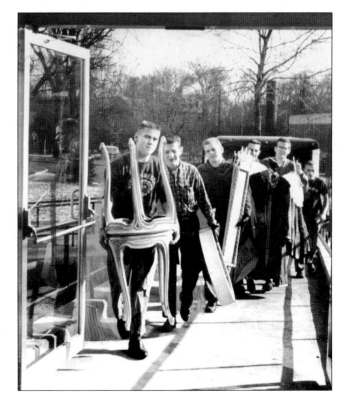

In this photograph, students bring in opera equipment for an upcoming event in 1962. Opera is a very important part of the curriculum at CIM. (Cleveland Press Collection, CSU).

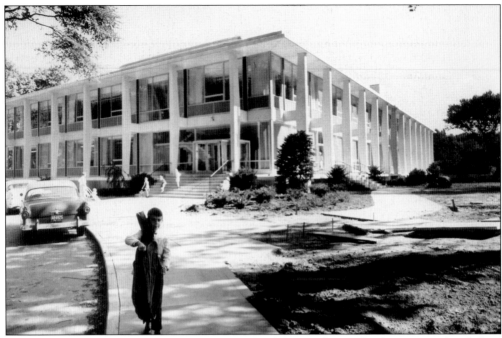

This cello student is probably wondering why he did not take up the flute or another lighter instrument. (Cleveland Press Collection, CSU.)

In 1958, a violin worth $6,500 was presented to CIM by industrialist Thomas Fawick (right). It was made in Paris in 1873 and is a copy of the famed Antonius Stradivarius. (Cleveland Press Collection, CSU.)

Pictured here is the brass and woodwind orchestra of 1949. CIM has always had a very special and close relationship to the world-famous Cleveland Orchestra. Many students and faculty are in both organizations. (Cleveland Press Collection, CSU.)

Are these ladies of Bourbon Street? No, they are students from the School of Cleveland Ballet for CIM's production of *Merry Widow* in 1980. (Cleveland Press Collection, CSU.)

Actors are usually told to break a leg, but pull a leg? (Cleveland Press Collection, CSU.)

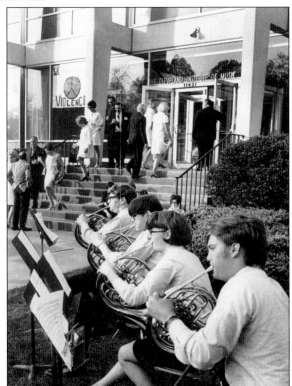

Pictured here is the "Brass on the Grass" concert in 1970. CIM offers many free concerts to the public. Where are the trumpet players? (Cleveland Press Collection, CSU.)

Two

THE MUSEUMS

University Circle is home to some of the world's finest museums. With so many museums located in such a concentrated area, it is no wonder that most Cleveland students get their first taste of University Circle on a school field trip.

Most visitors coming to University Circle from downtown or points west know that the Cleveland Museum of Art (CMA) is their doorway to the circle. CMA lies beyond Wade Lagoon, which overlooks Euclid Avenue. CMA is more than a building full of art pictures; it offers exhibitions, concerts, classes, lectures, and films; and because of its wealthy benefactors, CMA has free admission.

The Cleveland Museum of Natural History (CMNH) is one of the finest museums of its kind in the United States. There is the Shafran Planetarium, which illuminates 5,000 stars, planets, and constellations. The Wade Gallery houses 1,500 of the world's rarest jewels and gems. There are live animal exhibits, gardens, and, of course, dinosaurs.

The Western Reserve Historical Society (WRHS) is Cleveland's oldest cultural institution. The museum displays interesting artifacts that tell the story of the people and events that took place in the Western Reserve of northeastern Ohio. At the Crawford Auto-Aviation Museum (CAAM), visitors can explore nearly 200 vintage automobiles, aircraft, and bicycles. The property also has two mansions, a costume museum, and a library.

The Cleveland Health Museum or Healthspace Cleveland (HC) was a very interactive museum for people of all ages. HC was the nation's first museum of health and science, but it has recently had to close due to funding issues. However, its exhibits are being shown at the CMNH and in traveling exhibits.

The Children's Museum of Cleveland is the only museum in northeast Ohio solely dedicated to the education and development of young children. Since 1986, the museum has continued in its mission to provide exhibits, programs, and hands-on experiences that enhance early childhood learning. One of the most popular exhibits is the Big Red Barn, which brings the popular children's book by Margaret Wise Brown to life. There is also Bridges to our Community, which teaches cultural diversity, and Splish Splash, which teaches weather and the water cycle.

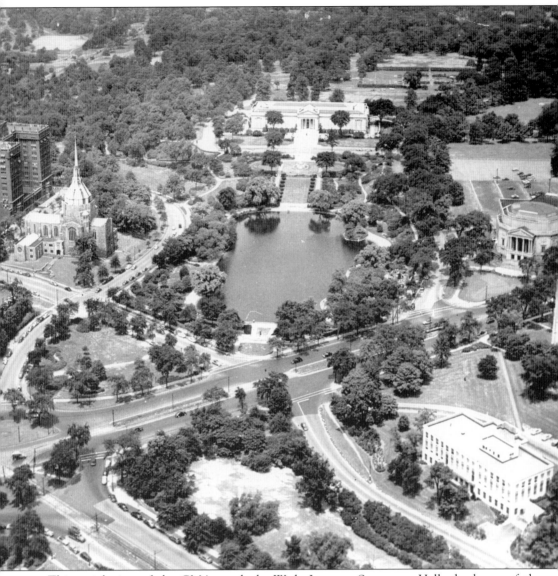

This aerial view of the CMA overlooks Wade Lagoon. Severance Hall, the home of the Cleveland Orchestra, is the building to the right of the lagoon. This picture clearly shows what a dominating position the CMA has in University Circle. (Cleveland Press Collection, CSU.)

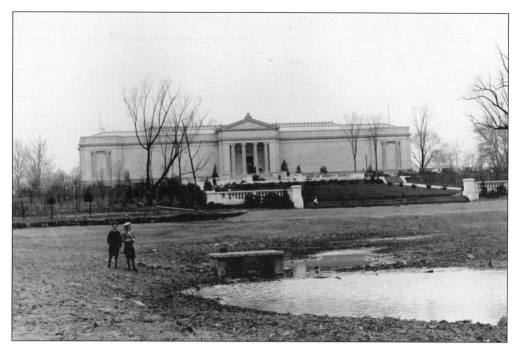

The CMA opened to the public in 1916. It was constructed in the neoclassical style with white Georgian marble. It cost $1.25 million to construct. This 1916 photograph shows a very different view than visitors see today. (Cleveland Press Collection, CSU.)

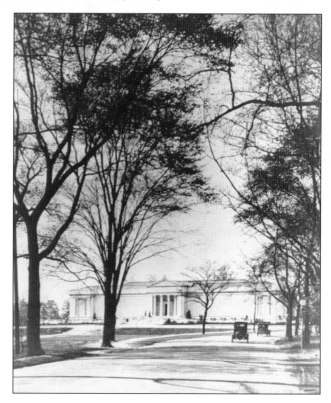

The land that CMA occupies was once owned by Jeptha Wade (1811–1890), president of the Western Union Telegraph Company. In 1881, Wade offered the city 75 acres of land for use as a park and an art museum. By 1850, Cleveland was a hub of telegraph lines that went all over the Midwest. (Cleveland Press Collection, CSU.)

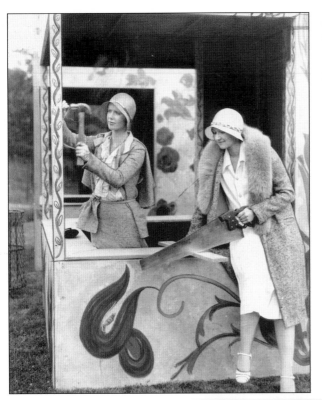

Society ladies Mrs. Sherwin and Mrs. Barnes help to set up the French Street Fair at CMA in 1930. Many of Cleveland's wealthiest citizens contributed money and resources to the success of CMA. (Cleveland Press Collection, CSU.)

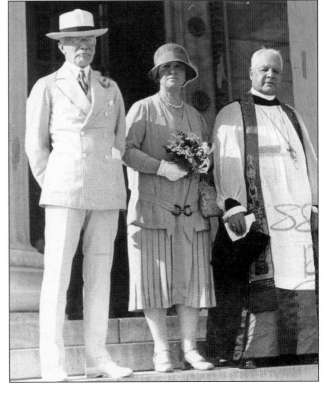

The three special guest speakers at a 1928 ceremony at CMA are, from left to right, William G. Mather, Mrs. John Sherwin, and Bishop William A. Leonard. The Sherwins made their fortune by cofounding the Sherwin-Williams Paint Company in 1866 in Cleveland. (Cleveland Press Collection, CSU.)

William G. Mather was so involved in Cleveland that he was known as Cleveland's "first citizen." His company was the Cleveland-Cliffs Steamship and Iron Company. The Cliffs flagship, the SS *William G. Mather*, is a maritime museum at Cleveland's North Coast Harbor. Mather served as president of CMA from 1933 to 1949. (Cleveland Press Collection, CSU.)

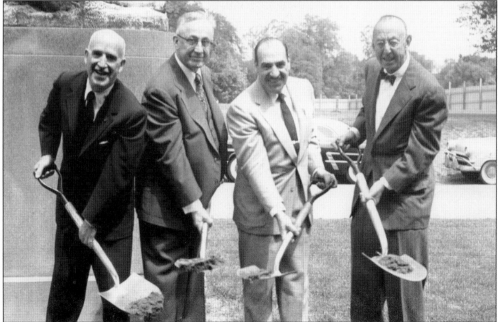

This was the 1955 groundbreaking for new $5 million wing. Pictured are, from left to right, CMA president William Milliken, Harold Clark, Mayor Anthony Celebrezze, and G. Garrison Wade, a relative of Jeptha H. Wade, who left the city the land to build the art museum. (Cleveland Press Collection, CSU.)

In 1971, CMA expanded and opened the education wing. The new wing had facilities for classrooms, lecture halls, and a library. Currently CMA is expanding its space for added exhibits and education. (Cleveland Press Collection, CSU.)

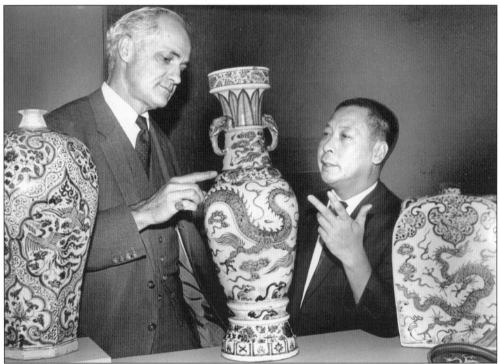

CMA director Dr. Sherman E. Lee and Wai-kam Ho, curator of Chinese Art, examine some Chinese vases in 1968. A generous bequest of $33 million by Leonard Hanna allowed CMA to acquire international, especially Asian, art. (Cleveland Press Collection, CSU.)

Some students dream about being a knight and saving the princess. CMA has a very expansive collection of armor and weaponry from the Middle Ages. (Cleveland Press Collection, CSU.)

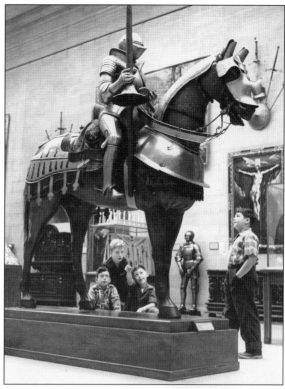

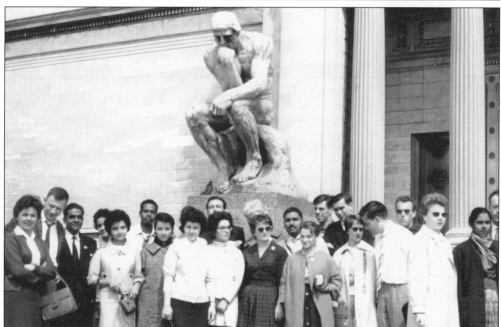

A group of social workers from 16 countries poses before CMA's *The Thinker* in 1961. *The Thinker* is considered one of Auguste Rodin's most famous works. Rodin worked for almost 10 years on *The Gates of Hell*, for which *The Thinker* was created. Rodin originally entitled his work *La Poet* (the poet). (Cleveland Press Collection, CSU.)

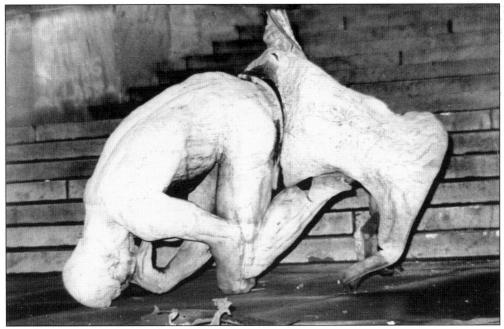

The Thinker is down for the count. At 1:00 a.m. on March 24, 1970, a bomb went off destroying the priceless work. No one was injured, but the attack was reported to be linked to a radical political group upset at the ongoing struggle in Vietnam. No one was ever charged with this unfortunate act of violence. (Cleveland Press Collection, CSU.)

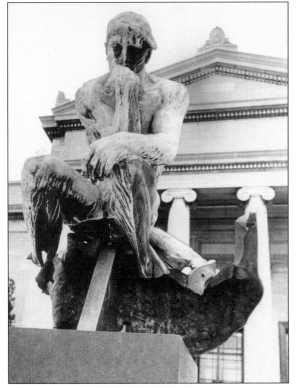

The decision was made to place the damaged statue back on its pedestal without fixing it. Cleveland, being one of only a few select cities to have *The Thinker*, has the only one that lacks legs. It is a vivid reminder of the political unrest that characterized the Vietnam War era in the United States. (Cleveland Press Collection, CSU.)

Volunteers decorate the CMA for the holidays. There is almost nothing more beautiful than Christmas time in University Circle after a snowfall. (Cleveland Press Collection, CSU.)

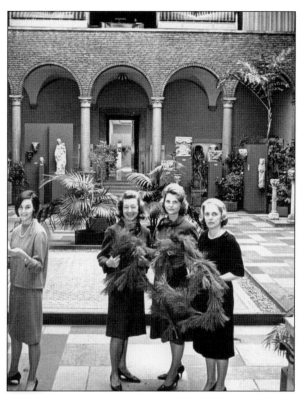

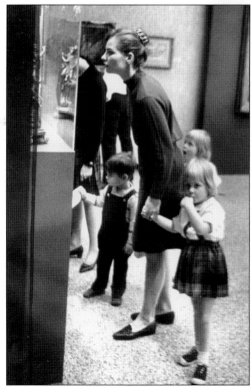

They will appreciate CMA much more when they get a little older. (Cleveland Press Collection, CSU.)

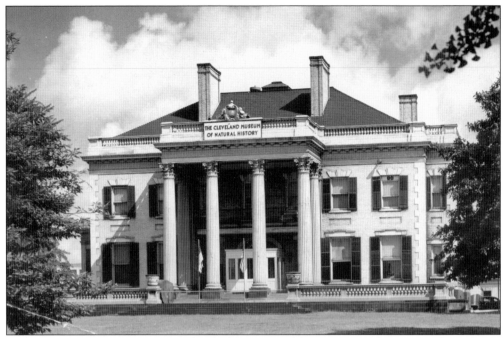

CMNH began as a two-room wooden building on Public Square in the 1830s. The "ark," as it was called, was filled with bird and mammal specimens. The museum moved to this Euclid Avenue mansion in 1920. (Cleveland Press Collection, CSU.)

In 1957, CMNH moved to its new $900,000 facility in University Circle. The 20,000-square-foot complex features galleries, exhibit space, a planetarium, an observatory, a museum store, and outside live animal exhibits. (Cleveland Press Collection, CSU.)

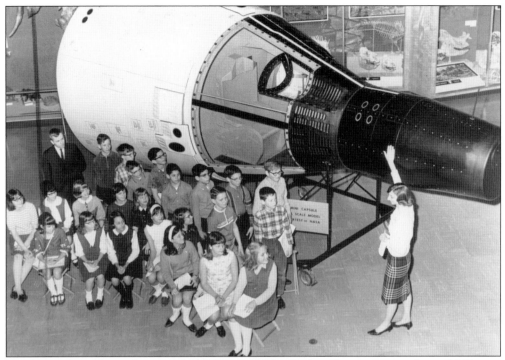

Marilyn Wolfe teaches a class about NASA in 1966. The Shafran Planetarium can locate 5,000 stars, nebulae, and galaxies. (Cleveland Press Collection, CSU.)

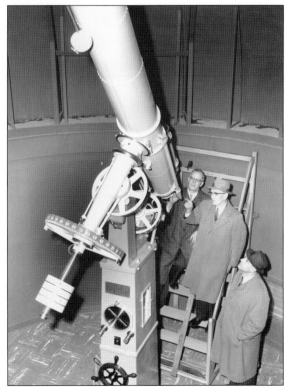

The Ralph Mueller Observatory houses a 105-year-old, 10.5-inch Wamer and Swasey Telescope. (Cleveland Press Collection, CSU.)

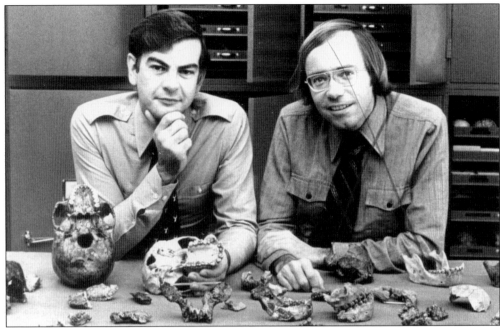

Dr. Donald Johnson (left) of CMNH and Dr. Tim White of the University of California at Berkeley show fossils of *Australopithecus afarensis* (after ape-man). These fossils were found in Ethiopia and are more than three million years old. The fossil's name is Lucy and she is on display at CMNH. (Cleveland Press Collection, CSU.)

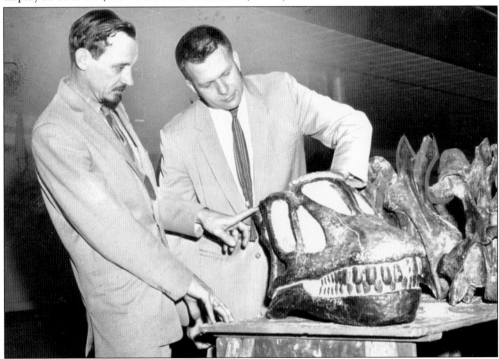

William Scheele of CMNH and George Whitaker of New York Museum of Natural History look over some dinosaur parts in 1959. (Cleveland Press Collection, CSU.)

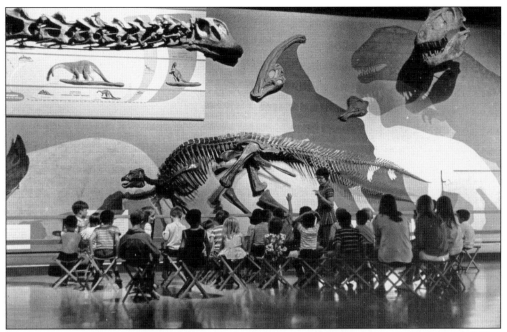

Students on a field trip to CMNH learn about dinosaurs. (Cleveland Press Collection, CSU.)

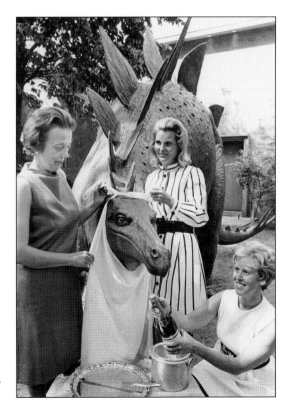

"Guess who's coming to dinner!" It is a good thing this stegosaurus is a vegetarian. (Cleveland Press Collection, CSU.)

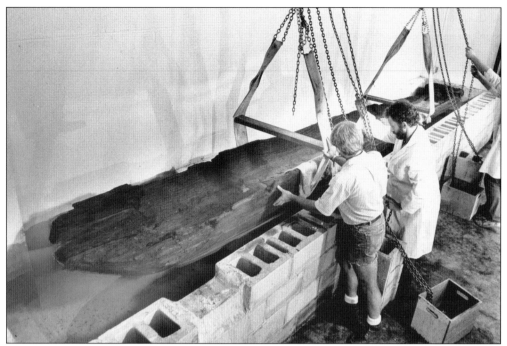

CMNH staff work on a 3,800-year-old Native American canoe. The object was found in a bog near Ashland in 1977. CMNH also conducts research and digs all over the world. (Cleveland Press Collection, CSU.)

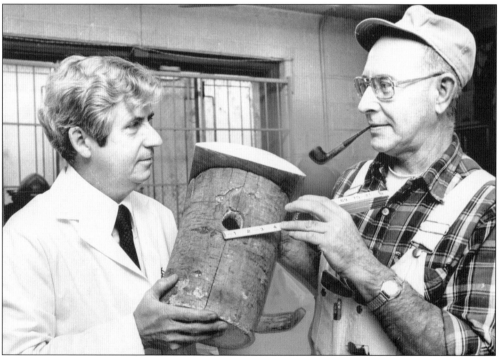

Dr. Harold Mahan (left), director of CMNH, stands with Bill Painter, the museum carpenter. (Cleveland Press Collection, CSU.)

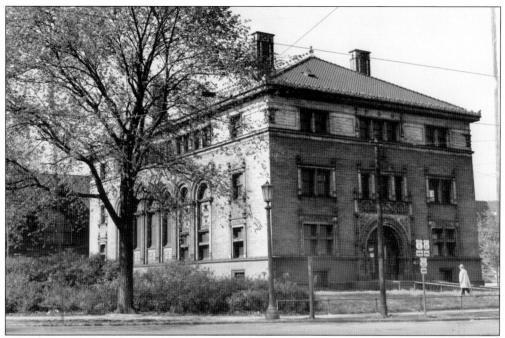

The Western Reserve Historical Society (WRHS) was founded in 1867 to preserve and present the history of northeast Ohio. The mansion that housed the collection was at East 107th Street and Euclid Avenue. (Cleveland Press Collection, CSU.)

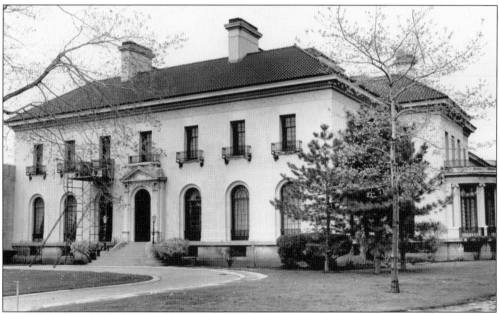

There are two mansions that flank the main WRHS building. This one is the Hay-McKinney House. It was built between 1908 and 1911 by Clara Stone Hay, daughter of Amasa Stone and widow of Secretary of State John Hay. She never lived in the house and ended up selling it to Price McKinney. The house was acquired by WRHS and opened as a museum in 1939. (Cleveland Press Collection, CSU.)

Next to the Hay-McKinney property, Henry Bingham built a 35-room mansion between 1916 and 1919. In 1920, Coralie Hanna, widow of Leonard C. Hanna, bought the house. After her death, her son traded it for the historical society's property on East 107th Street and Euclid Avenue. The WRHS moved to its present location on East Boulevard in 1940. (Cleveland Press Collection, CSU.)

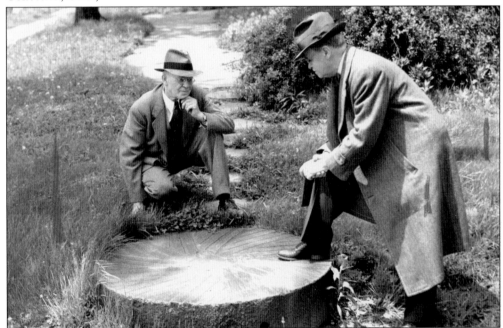

Dr. E. J. Benton examines the original runner stone in 1943. The runner stone is the uppermost of a pair of working millstones. The runner stone spins above the stationary bed stone, creating a grinding action to make corn and wheat into cornmeal and flour. (Cleveland Press Collection, CSU.)

The Chisholm Halle Costume Wing inside the WRHS has 30,000 artifacts ranging from belongings of the rich and powerful to those of the servants that cared and worked for them. (Cleveland Press Collection, CSU.)

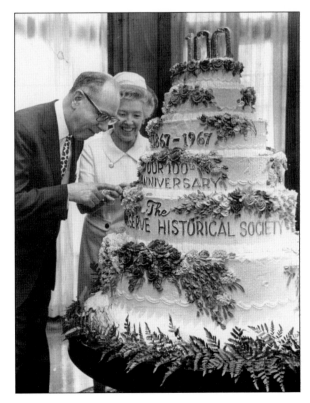

WRHS celebrates its centennial birthday in 1967. Happy birthday, WRHS. (Cleveland Press Collection, CSU.)

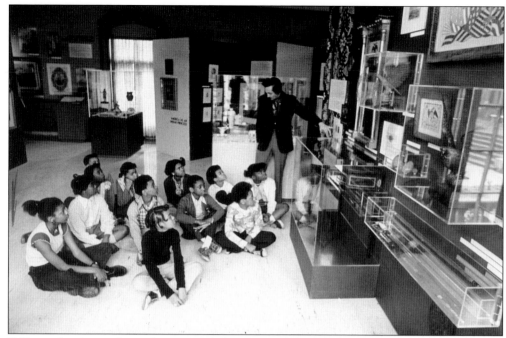

Fifth graders learn about the country's bicentennial birthday in 1976. WRHS is a popular field trip because of the many educational and interactive programs it offers. (Cleveland Press Collection, CSU.)

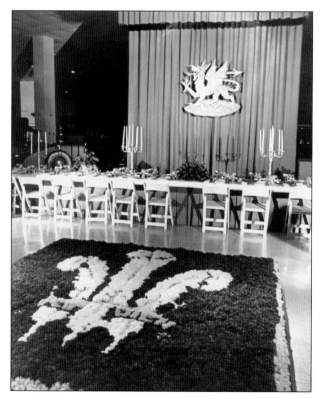

The setting of a visit by Great Britain's Prince Charles in 1977 is seen in this photograph. On his tour of Cleveland, he made a point of visiting the Crawford Auto-Aviation Museum, which is a part of WRHS. (Cleveland Press Collection, CSU.)

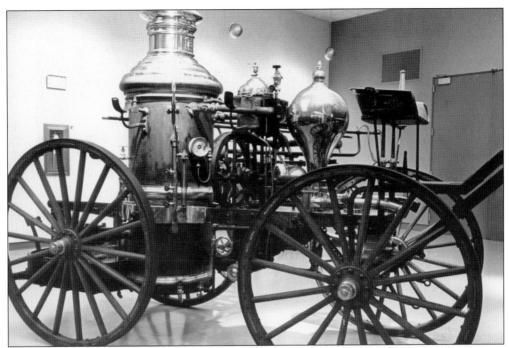

This is a very rare piece of fire equipment. This is Fire Engine No. 2. The Cleveland Fire Department traces its history back to 1829 with the volunteer Live Oaks No. 1, which never received any equipment until 1833. (Cleveland Press Collection, CSU.)

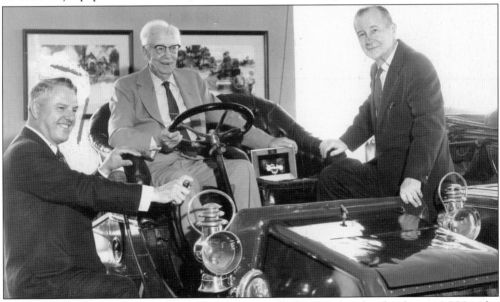

John R. Blakeslee climbs into the seat of the two-cylinder Winton that he drove 10,000 miles in a 1904 contest in which he won the Silver Cup. He joined the Cleveland Auto Club in 1901, one year after it opened. He was arrested for crossing the Superior Viaduct at 12 miles per hour, when the speed limit was eight miles per hour. Gas cost 9¢, and when going up a steep hill, the car had to be driven up backwards to keep the gas going to the engine. (Cleveland Press Collection, CSU.)

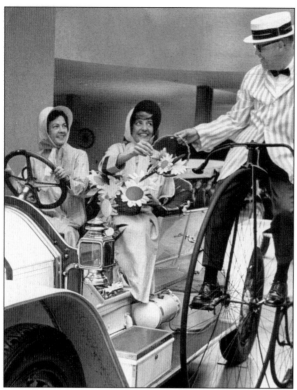

The Spring Fling raised money for Fairview Hospital in 1965. Not many people today receive flowers by a man on a bike with a very large front tire. (Cleveland Press Collection, CSU.)

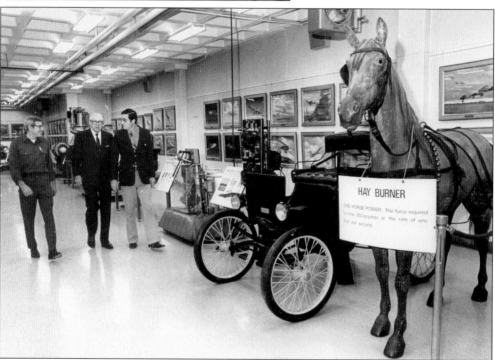

It looks like someone may be out of a job. Maybe the sign could say, "Will work for hay." (Cleveland Press Collection, CSU.)

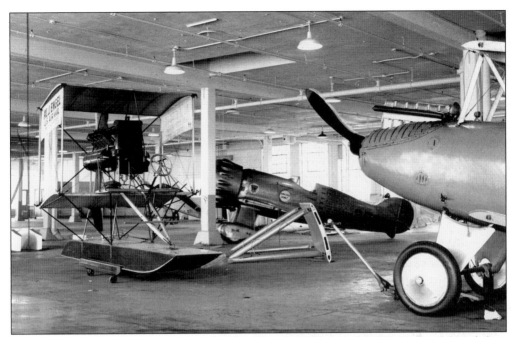

A historic aircraft is being moved to the new Crawford Wing at WRHS. Pictured from left to right are Al Engel's 1911 Curtiss Pusher, Roscoe Turner's Wendell-Williams racer, and Casey Jones's Curtiss Oriole 1920 biplane. The Crawford Auto-Aviation Museum was founded due to the efforts of Frederick C. Crawford. (Cleveland Press Collection, CSU.)

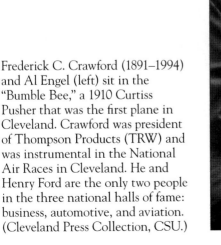

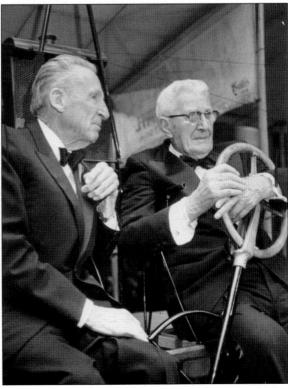

Frederick C. Crawford (1891–1994) and Al Engel (left) sit in the "Bumble Bee," a 1910 Curtiss Pusher that was the first plane in Cleveland. Crawford was president of Thompson Products (TRW) and was instrumental in the National Air Races in Cleveland. He and Henry Ford are the only two people in the three national halls of fame: business, automotive, and aviation. (Cleveland Press Collection, CSU.)

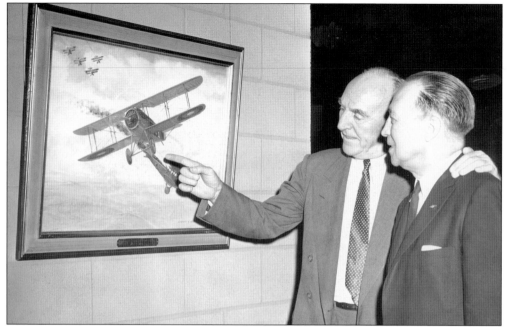

World War I fighter ace Eddie Rickenbacker (left) is seen here with Charles Hubbell, Thompson Products aviation artist, in 1957. Rickenbacker started the war as a driver for Gen. John Pershing but was finally accepted into the air service. He had 26 kills and was awarded the Congressional Medal of Honor. (Cleveland Press Collection, CSU.)

Jimmy Doolittle (left) is pictured here with Walter Cronkite in 1981. Doolittle launched the first carrier-based air raid on mainland Japan in 1942, for which he was awarded the Congressional Medal of Honor. (Cleveland Press Collection, CSU.)

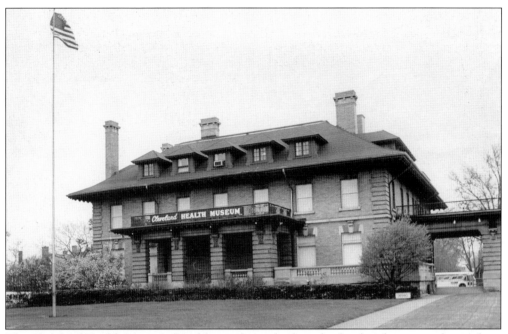

The Cleveland Health Museum (Healthspace) was the first of its kind in the western hemisphere when it opened in 1936. Although the museum has recently closed, its exhibits still travel. In the past, the traveling exhibits have reached 45,000 students in 25 states and three countries. (Cleveland Press Collection, CSU.)

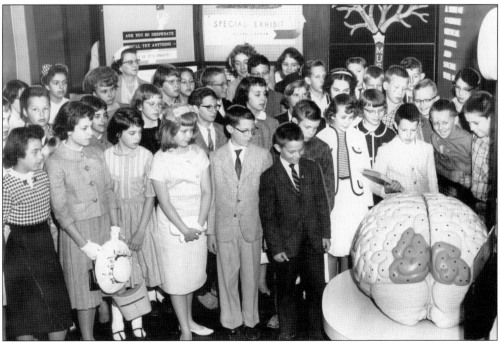

Sixth-grade students from Russell Elementary School in rural Geauga County examine the brain in 1960 at the health museum. The highlight of the trip was lunch at a "big city" restaurant. (Cleveland Press Collection, CSU.)

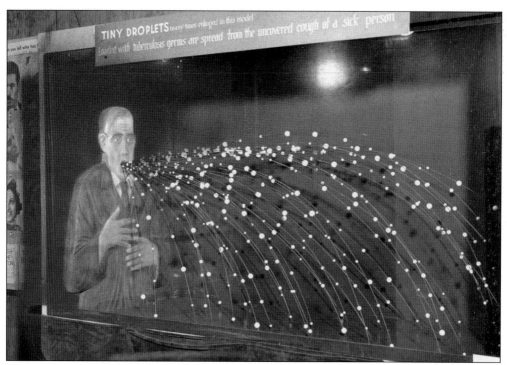

This is why a mother tells her kids to cover their mouths when they cough. (Cleveland Press Collection, CSU.)

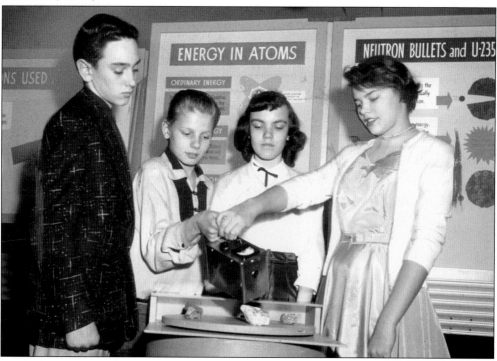

During the height of the cold war, students learn about how a Geiger counter works. (Cleveland Press Collection, CSU.)

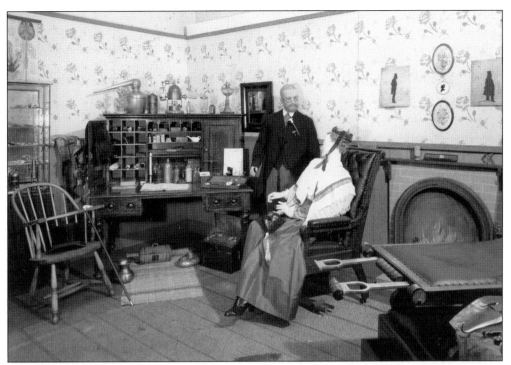

Shown here is a replica of a doctor's office in late-19th-century America. (Cleveland Press Collection, CSU.)

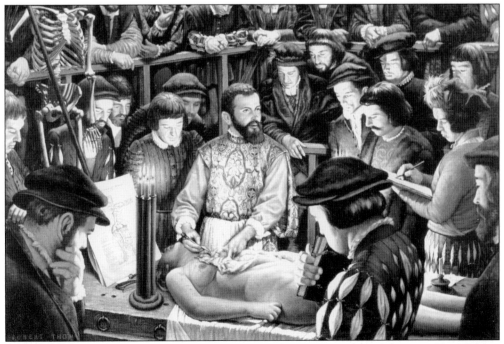

This painting is of Andreas Vesalius of Brussels, the first great teacher of anatomy. He taught at the University of Padua from 1537 to 1543 and wrote *De Humani Corporis Fabrica*, a classic in medical literature. (Cleveland Press Collection, CSU.)

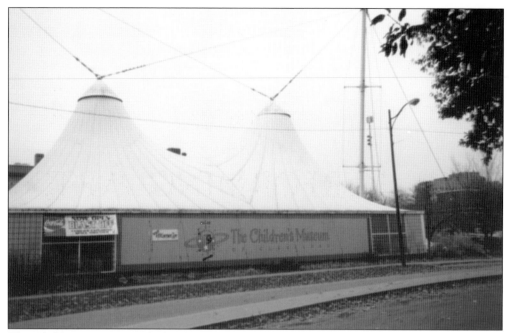

The Children's Museum of Cleveland was founded in 1981. It is closely allied with Rainbow Babies and Children's Hospital. The exhibits are interactive and hands-on. (Photograph by the author.)

One of the most popular areas in the children's museum is the Big Red Barn room, named after the famous children's book by the same name. (Cleveland Press Collection, CSU.)

Three

THE PERFORMING ARTS

University Circle is home to a variety of performing arts. From the world-famous Cleveland Orchestra to modern dance and independent film releases, University Circle has it all.

The Cleveland Orchestra stands today among the world's most revered symphonic ensembles. The orchestra was founded in 1918. It first played in Gray's Armory and later in the Cleveland Masonic Auditorium. In 1931, the orchestra moved to its permanent home in University Circle at Severance Hall. The hall was primarily the gift of John L. Severance as a memorial to his wife, Elizabeth.

Severance Hall is hailed as one of America's grandest concert halls. The orchestra plays there during the months of September through May. Severance Hall can seat 2,100 in the main concert hall and cost $7 million to build. Severance Hall was named in honor of John and Elizabeth. Elizabeth's father had been treasurer for John D. Rockefeller's Standard Oil Company and was president of the board for the orchestra. Elizabeth died before the hall was completed, and John ended up giving $3 million toward its completion.

In the summer months, the orchestra's home is Blossom Music Center in Cuyahoga Falls, 25 miles south of Cleveland. Blossom Music Center was named for the Blossom family, which had been a great supporter of the orchestra throughout its history and was friends of the Severances. The capacity of the center can reach nearly 14,500. Other big name venues use the center during the touring season.

The Cleveland Play House is nationally recognized as America's first resident theater and the longest-running regional theater in the United States. It presents new, contemporary and classic plays, comedies, and musicals. It also produces three children's plays each year for elementary school students. Many famous people are among its alumni, including Alan Alda, Paul Newman, Margaret Hamilton, and Jack Weston. Another wonderful theater in the play house is the Cleveland Signstage Theatre where plays are performed in both American Sign Language and spoken English.

After a $1.4 million renovation in 2003, Wade Park has a beautiful performance stage for outdoor concerts. There is almost no better place to see a performance than in University Circle's Wade Park on a warm summer evening with the backdrop of the CMA and Severance Hall.

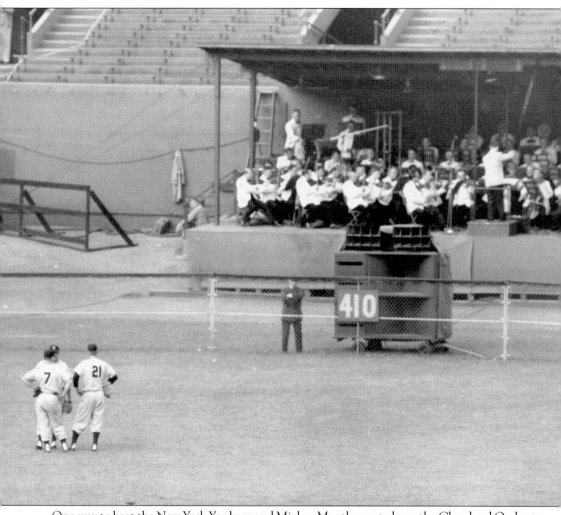

One way to beat the New York Yankees and Mickey Mantle was to have the Cleveland Orchestra play a concert at Cleveland Municipal Stadium in 1953. (Cleveland Press Collection, CSU.)

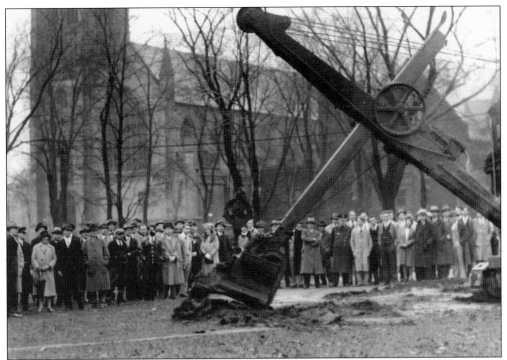

A steam shovel breaks ground in 1929 for Cleveland Orchestra's new home, Severance Hall. (Cleveland Press Collection, CSU.)

John L. Severance gave $1 million to help with the costs for the new concert hall. He would end up giving three times that amount before the project was finished. (Cleveland Press Collection, CSU.)

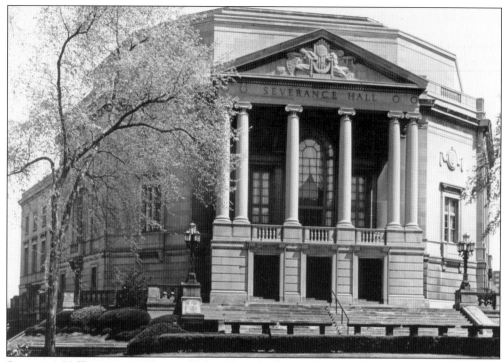

Severance Hall's interior is reportedly based on the lacework on Elizabeth Severance's wedding dress. (Cleveland Press Collection, CSU.)

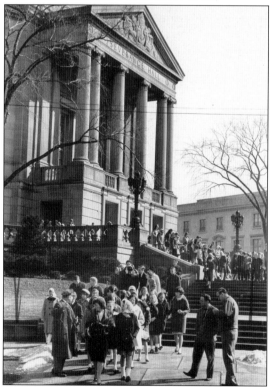

This is a 1965 children's concert. The Cleveland Orchestra offers many different types of concerts for the public. (Cleveland Press Collection, CSU.)

This is a 1931 view of the stage at Severance Hall. The hall's Norton Memorial Organ has 6,025 pipes ranging in size from 32 feet tall to seven inches tall. (Cleveland Press Collection, CSU.)

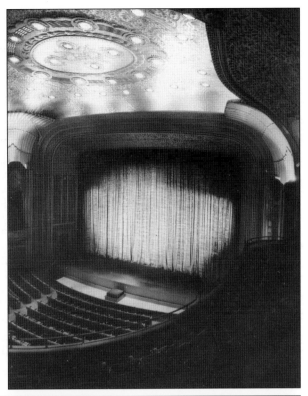

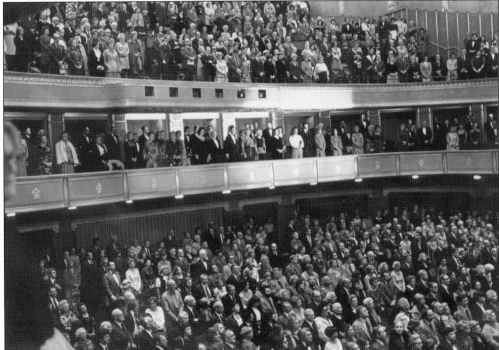

It is standing room only when Great Britain's Prince Charles drops in to hear the orchestra in 1977. (Cleveland Press Collection, CSU.)

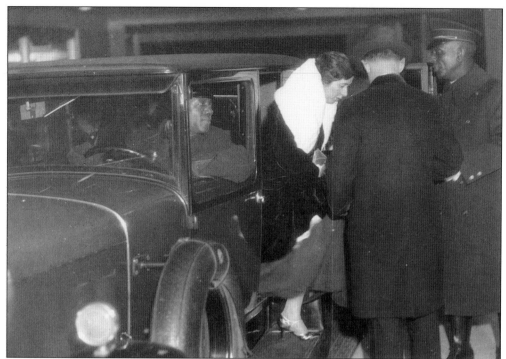

Cleveland society arrives for opening night at Severance Hall on February 5, 1931. (Cleveland Press Collection, CSU.)

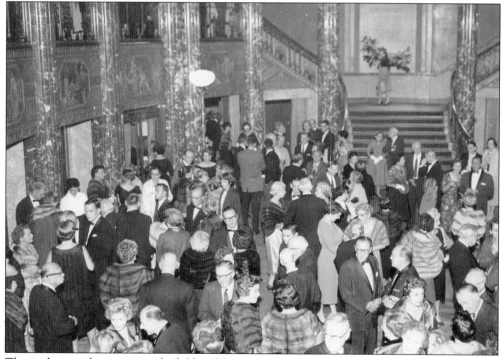

This is the grand staircase in the lobby of Severance Hall on opening night in 1959. (Cleveland Press Collection, CSU.)

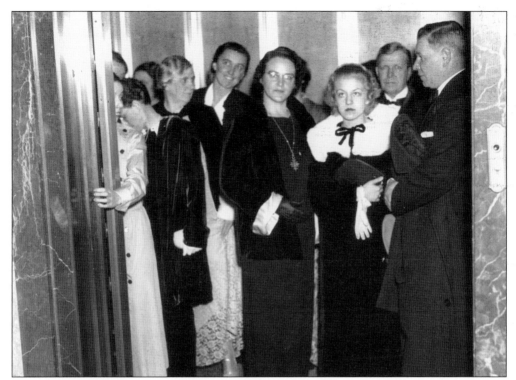

"Hold that elevator!" (Cleveland Press Collection, CSU.)

There does not seem to be a seat anywhere for Mrs. Walter Bailey and Mrs. Frank Joseph in 1960. (Cleveland Press Collection, CSU.)

Conductor Charles Darden holds tryouts for the Cleveland Orchestra. (Cleveland Press Collection, CSU.)

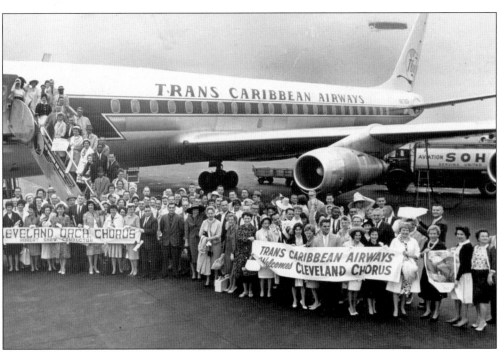

A warm welcome for the orchestra in 1962 is pictured here. (Cleveland Press Collection, CSU.)

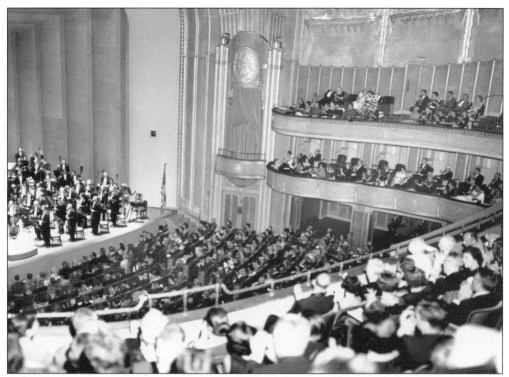

The orchestra plays to another full house in 1958. (Cleveland Press Collection, CSU.)

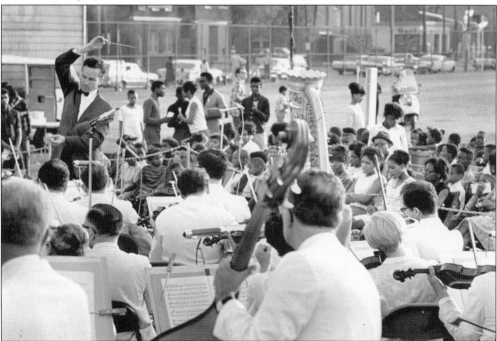

Even Cleveland's famed League Park played host to the Cleveland Orchestra. League Park hosted two very famous events in baseball history, Babe Ruth's 500th home run and the ending of Joe DiMaggio's legendary 56th consecutive game with a hit. (Cleveland Press Collection, CSU.)

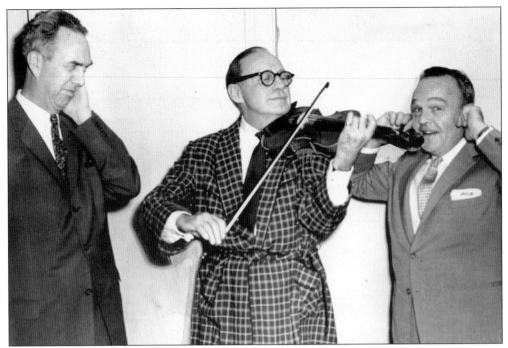

Jack Benny goes on playing as Dudley Blossom (right) expresses ear trouble. Benny appeared with the Cleveland Orchestra to help raise funds for pensions in 1960. (Cleveland Press Collection, CSU.)

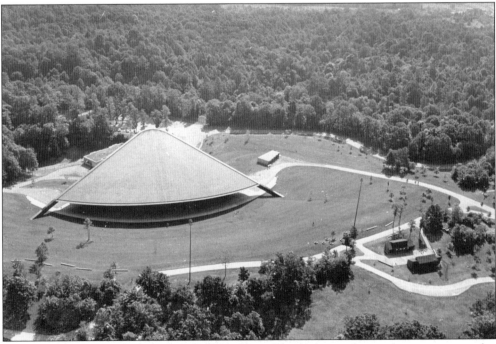

Blossom Music Center in Cuyahoga Falls is the orchestra's home during the summer months. There is nothing like a concert there after a long rainstorm the night before. (Cleveland Press Collection, CSU.)

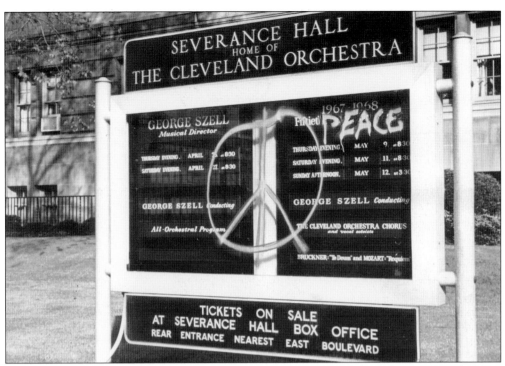

Even the Cleveland Orchestra could escape the political turmoil of the 1960s and 1970s. (Cleveland Press Collection, CSU.)

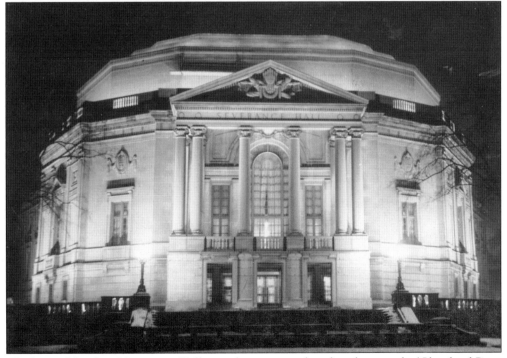

The beautiful sight of Severance Hall at night is captured in this photograph. (Cleveland Press Collection, CSU.)

The Cleveland Play House was established in 1915 as America's first professional theater company. Some of the biggest names in Hollywood began their careers here, like Hal Holbrook, Tom Hanks, and Ed Asner. (Cleveland Press Collection, CSU.)

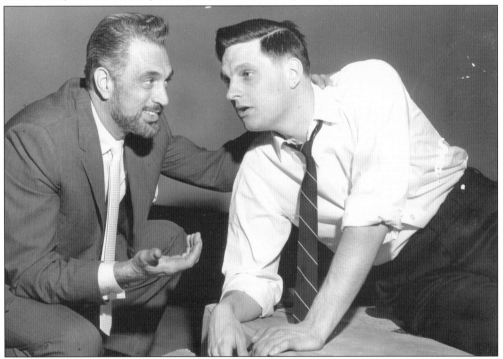

A young Alan Alda, before playing Hawkeye on M*A*S*H, is pictured with his father, Robert, on the set of *Job,* for which Alan had the leading role in 1959. (Cleveland Press Collection, CSU.)

Four

HEALTH CARE AND SOCIAL SERVICE

Many visitors from other states and countries come to the Steamship William G. Mather Museum. When asked why they are visiting Cleveland, they inevitably say that they are here for treatment or visiting someone who is getting treatment at one of the two greatest health care facilities in the country, University Hospitals or the Cleveland Clinic.

University Hospitals of Cleveland is a nationally recognized academic medical center. Its main campus includes Rainbow Babies and Children's Hospital, University MacDonald Women's Hospital (Ohio's only women's hospital), and University Ireland Cancer Center. Together with CWRU, they form the largest biomedical research center in the state of Ohio. University Hospitals Health System serves people at 150 locations throughout northern Ohio.

The Cleveland Clinic Foundation integrates clinical and hospital care with research and education. It is a private, nonprofit group practice that includes a 954-bed hospital, outpatient services, a research institute, and an education foundation. Like University Hospitals, the Cleveland Clinic operates hospitals and health centers throughout northern Ohio.

The Louis Stokes Veterans Administration Medical Center has been recognized by the National Veterans Health Administration for programs of excellence in open-heart surgery, domiciliary care for the homeless, HIV/AIDS care, care of the mentally ill, and care of substance abuse. More than 1,000 students are trained at the medical center every year.

There are also many other social service agencies in the University Circle community. The Cleveland Sight Center is one of the most comprehensive service providers in the country for people who are visually impaired or blind. It just celebrated its 100th anniversary in the Cleveland area. The sight center provides services for children, adults of working age, and seniors.

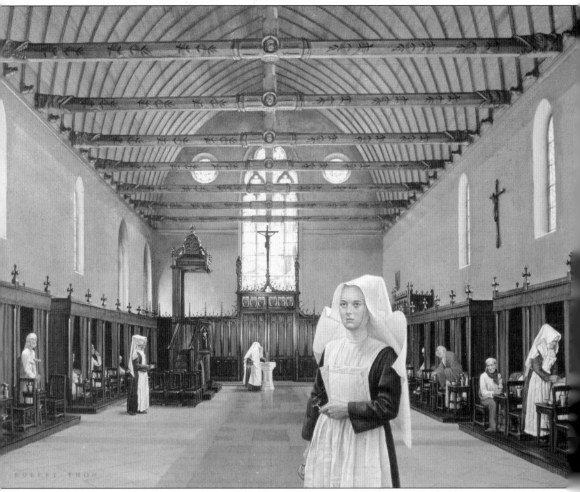

The Great Room of the Poor (La Grand' Chambre des Povres) is believed to be the first hospital. Founded in 1443 in France and run by the Sisters of the Congregation of Sainte Marthe, it survived over 500 years and countless wars. (Cleveland Press Collection, CSU.)

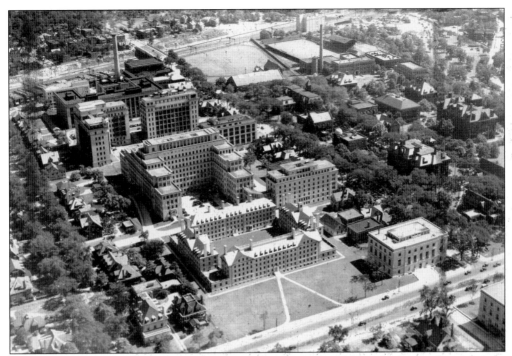

This 1940 view shows the University Hospitals campus in University Circle. Its proximity to CWRU meant that the two would have a close working relationship. (Cleveland Press Collection, CSU.)

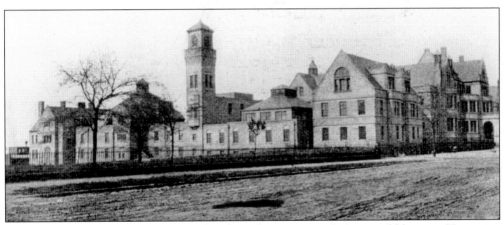

This is Lakeside Hospital in 1898. Lakeside is the ancestor of what would become University Hospitals. Lakeside traces its roots back to the Civil War when the Ladies Aid Society of the First Presbyterian Church ("Old Stone Church") opened a "Home for the Friendless" to aid refugees displaced by the war. (Cleveland Press Collection, CSU.)

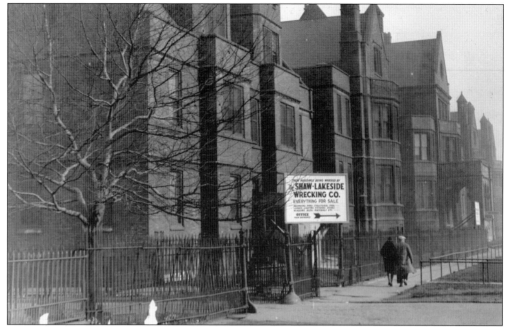

The Lakeside Hospital is ready to be demolished by Shaw-Lakeside Wrecking Company in 1931. Today University Hospitals offers 150 satellite offices throughout northern Ohio. Together with CWRU, it forms the largest biomedical research center in the state of Ohio. (Cleveland Press Collection, CSU.)

The new University Hospitals campus was located in University Circle in 1927. University Hospitals includes the famous Rainbow Babies and Children's Hospital, the Ireland Cancer Center, and MacDonald Women's Hospital, Ohio's only hospital dedicated to women. (Cleveland Press Collection, CSU.)

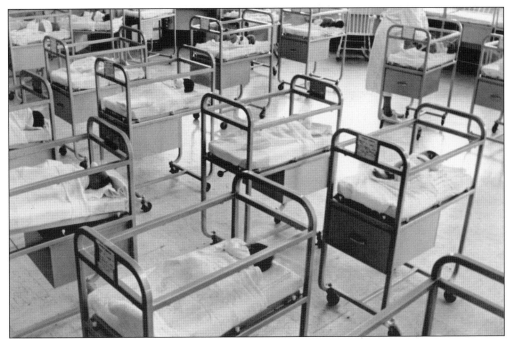

This is the Rainbow Babies and Children's Hospital. Rainbow was founded more than 110 years ago to treat the children of Cleveland. Some 10,000 children are treated every year by this cutting-edge hospital. (Cleveland Press Collection, CSU.)

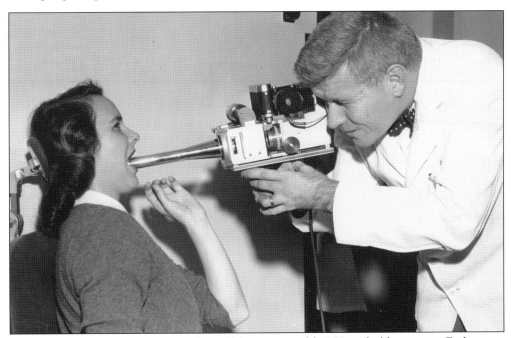

This doctor was not kidding when he told her to say "ahh!" He is holding a new Endoscopic camera, which takes color pictures within any body cavity to aid the fight against cancer. It uses a telephoto lens that cost $3,700 and was given to University Hospitals by the American Cancer Society in 1957. (Cleveland Press Collection, CSU.)

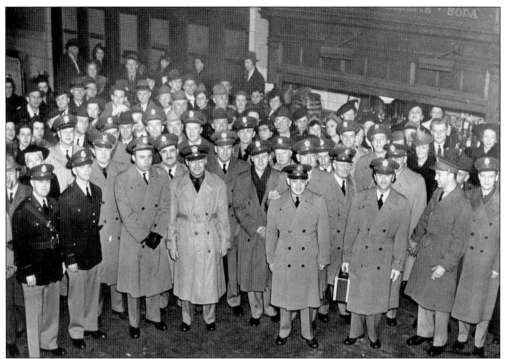

University Hospitals's doctors from the Lakeside Unit were the first medical unit activated during World War II and went to the Pacific Theatre in 1941. (Cleveland Press Collection, CSU.)

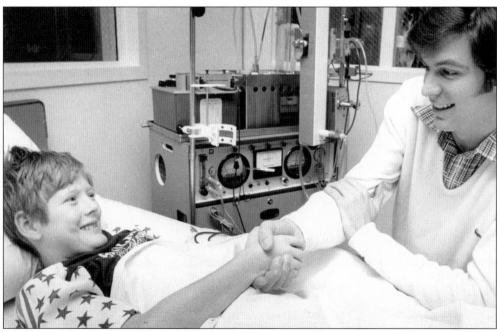

University Hospitals's kidney dialysis patient Doug Martin shakes hands with Cleveland Cavaliers basketball star John Lambert. A game against the Washington Bullets benefited the kidney dialysis center that was built at the hospital in 1976. (Cleveland Press Collection, CSU.)

Five-year-old Michael Shelling was the national poster child for the Hemophilia Foundation. He is being treated at University Hospitals in 1971. (Cleveland Press Collection, CSU.)

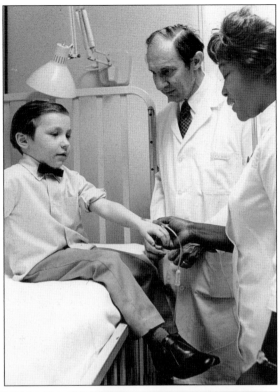

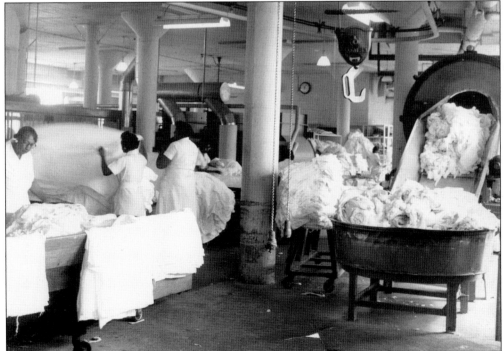

In 1960, workers in the laundry room were doing nine million tons of laundry every day. (Cleveland Press Collection, CSU.)

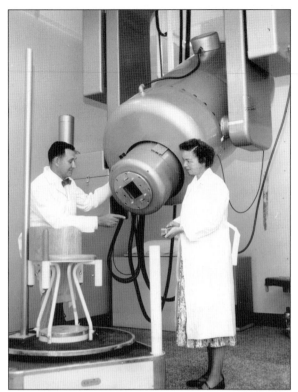

At a cost of $80,000, this 1955 Van de Graaff machine generates two million volts that treat even the minutest cancers in the body. (Cleveland Press Collection, CSU.)

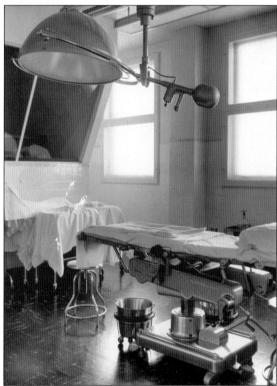

This 1956 University Hospitals maternity room seems very cold, especially with those little robes they give patients to wear. (Cleveland Press Collection, CSU.)

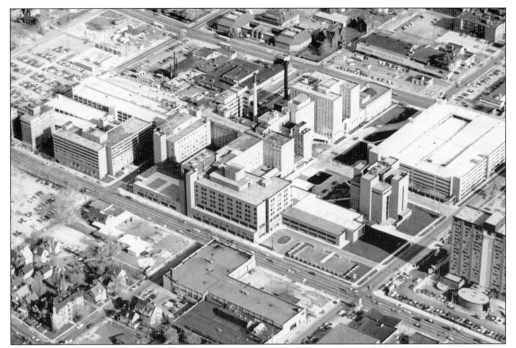

This aerial view, taken in 1976, shows the Cleveland Clinic campus. The clinic was founded in 1921 by Dr. George Crille and three other like-minded doctors who wanted to provide outstanding care based on cooperation, compassion, and innovation. (Cleveland Press Collection, CSU.)

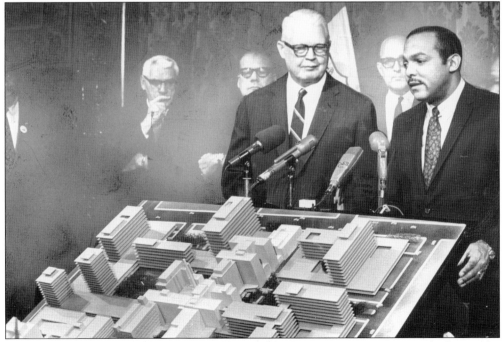

Cleveland mayor Louis Stokes and Cleveland Clinic chairman Dr. Fay LeFievre look over the plans for expansion in 1968. Cleveland Clinic is one of the largest hospitals in the country and the largest employer in Cleveland. (Cleveland Press Collection, CSU.)

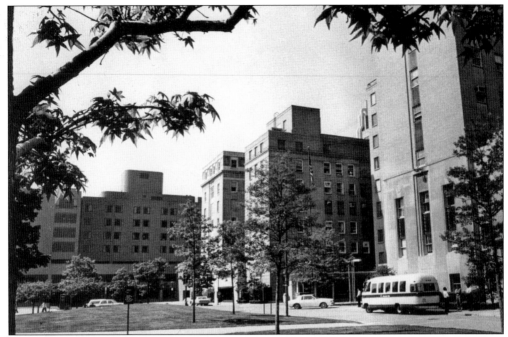

The Cleveland Clinic serves more than one million patients every year in 120 medical specialties. The Heart and Vascular Institute is continually ranked as number one in the United States. (Cleveland Press Collection, CSU.)

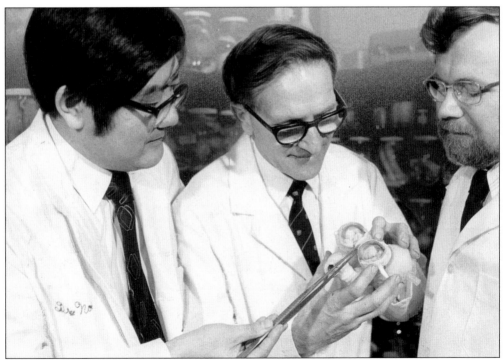

Cleveland Clinic doctors and professors inspect an artificial heart that was developed at the Cleveland Clinic in 1974. (Cleveland Press Collection, CSU.)

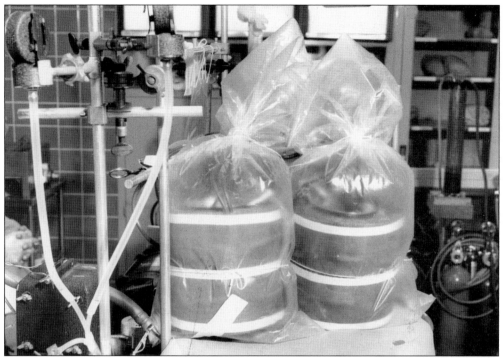

These are artificial lungs used in 1956 at the Cleveland Clinic. (Cleveland Press Collection, CSU.)

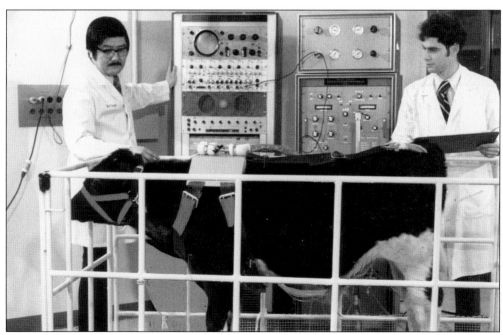

Cleveland Clinic doctors measure a calf that has lived with an artificial heart developed at the Cleveland Clinic. The rubber diaphragm in the heart was developed by the Goodyear research department, which is part of the Akron-based Goodyear Tire and Rubber Company. (Cleveland Press Collection, CSU.)

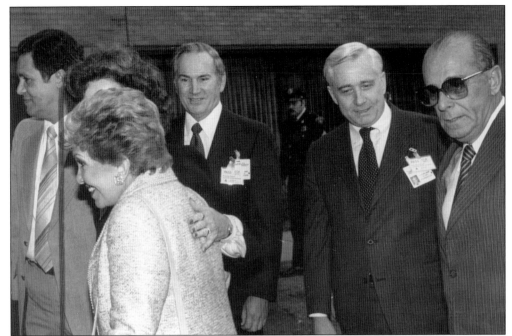

Pres. Joao Baptista de Oliveira Figueiredo of Brazil visits the Cleveland Clinic for treatment in 1981. Many foreign dignitaries visit the Cleveland Clinic for their treatments, giving Cleveland an international reputation as the place to be if one is sick. (Cleveland Press Collection, CSU.)

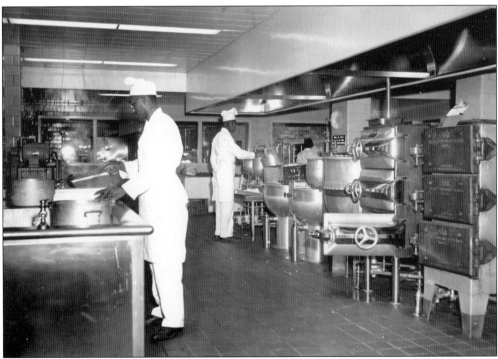

This 1955 view shows the staff in the Cleveland Clinic preparing meals. (Cleveland Press Collection, CSU.)

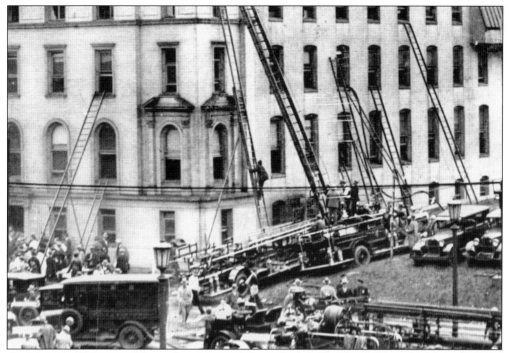

On May 14, 1929, a terrible explosion ripped through this Cleveland Clinic building. It is one of Cleveland's most infamous disasters. The lethal fire was caused by nitrate-based x-ray films stored too close to a lightbulb. (Cleveland Press Collection, CSU.)

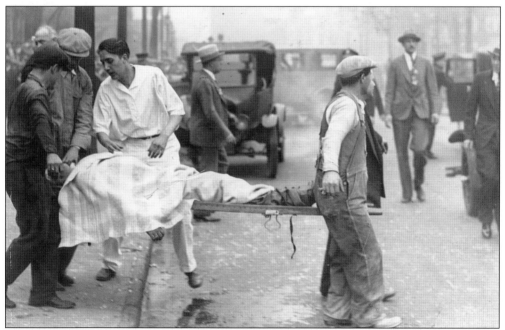

Emergency personnel are trying to evacuate all the injured from the building. Unfortunately, many rescuers inhaled the deadly fumes and gases while trying to help. (Cleveland Press Collection, CSU.)

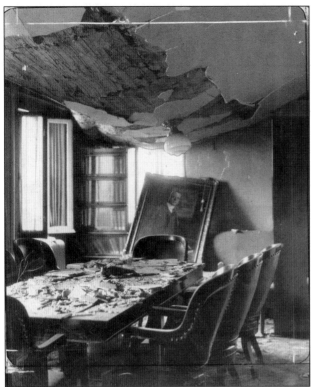

Luckily no one was sitting at the head of this table. In all, 123 people lost their lives, including Dr. John Phillips who was one of the original founders of Cleveland Clinic. The disaster caused changes that would be felt throughout the entire country, like the firefighters receiving gas masks as part of their equipment and the creation of an ambulance service. (Cleveland Press Collection, CSU.)

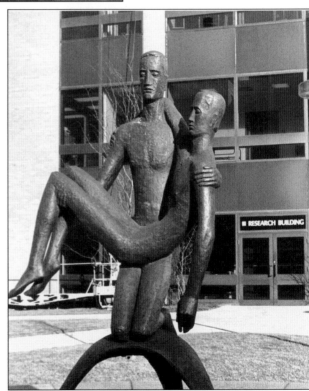

This sculpture is called *Man Helping Man*. It is located on the Cleveland Clinic campus. In tragedies, the true humanity of people comes out. (Cleveland Press Collection, CSU.)

The Cleveland Veterans Administration Medical Center has two locations, one in University Circle and one in Brecksville. (Cleveland Press Collection, CSU.)

The Veterans Administration claims office was busy after World War II in 1946. (Cleveland Press Collection, CSU.)

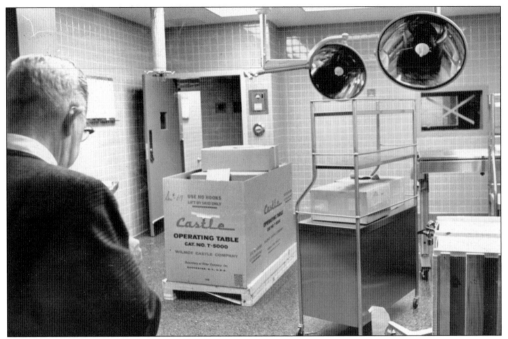

Workers are getting the operating room ready in 1964. The Louis Stokes Veterans Administration Medical Center is a fully functioning hospital that can perform all the functions of a private hospital. (Cleveland Press Collection, CSU.)

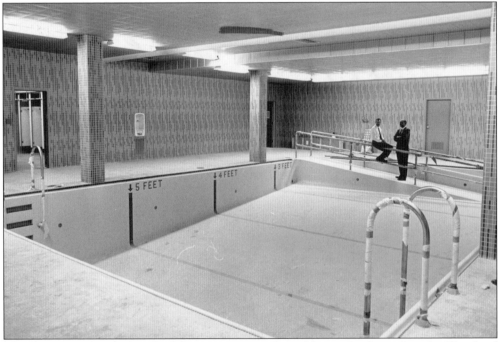

The therapy pool with the wheelchair ramp is seen here. The pool is located in the Cleveland Veterans Administration Medical Center at the Wade Park facility. Water therapy is an important part of rehabilitation. (Cleveland Press Collection, CSU.)

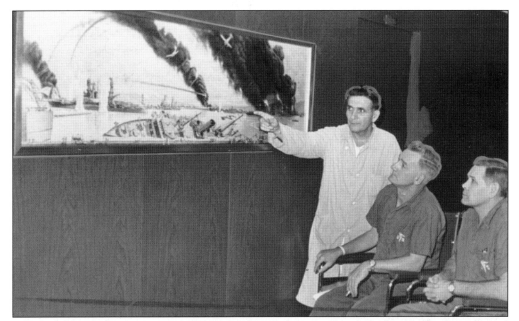

Veterans Administration patients look at a painting of the December 7, 1941, attack on Pearl Harbor by the Japanese Empire. This photograph was taken in 1966, 25 years after the attack. Reese Lewis (left) is an army veteran of the attack, John D. Warren (center) was a crewman aboard the USS *San Francisco* during the attack, and E. W. Boggs was in the Army Air Corps stationed in the Philippines on December 7, 1941. (Cleveland Press Collection, CSU.)

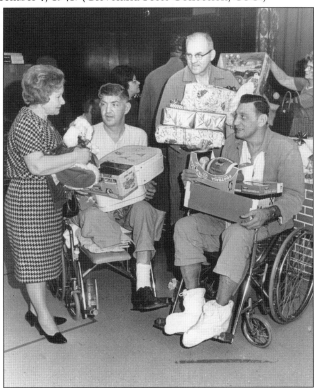

Santa has not forgotten the veterans at the Veterans Administration center. The gifts for the patients and their families were all bought and paid for by donations from the community and organizations. (Cleveland Press Collection, CSU.)

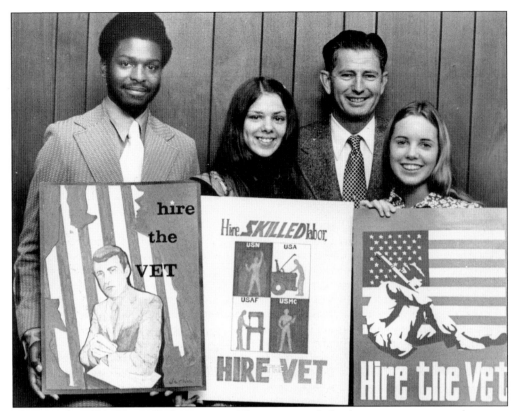

This was the 1972 "Hire a Vet" campaign. The campaign helped veterans secure employment. Employment applications began to ask applicants of their veteran status. (Cleveland Press Collection, CSU.)

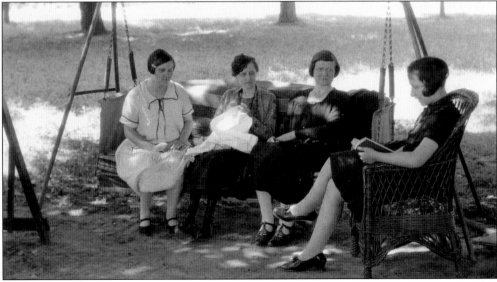

This is a 1927 outdoor reading class for patients of the Cleveland Sight Center. It was started in 1906 to enable people who were blind or visually impaired to reach their full potential in life. (Cleveland Press Collection, CSU.)

Five

GARDENS AND PARKS

University Circle is home to many beautiful buildings and sculptures, but the gardens and parks of the circle are a true gem to the city of Cleveland. What is great about University Circle is that the green space is actually used for activities such as art walks, concerts, history tours, and carnivals. Being outside in University Circle is as much fun as being inside.

The Cleveland Botanical Garden's showpiece is the Eleanor Armstrong Smith Greenhouse, which features flora and fauna from two diverse ecosystems in the world. One is the spiny desert of Madagascar, and the other is a Costa Rican cloud forest. Visitors will also enjoy the 10 acres of beautiful landscaped gardens including a rose garden, a Japanese garden, the Western Reserve Herb Society Garden, and the Hershey Children's Garden. Besides their home base in University Circle, Cleveland Botanical Garden offers off-site urban learning gardens and outdoor classrooms at Cleveland schools.

The Cleveland Cultural Gardens are located inside Rockefeller Park. Each garden represents an ethnic group that called Cleveland its home in America. Although each garden is unique, they all collectively represent an ethnic city working together. In all, there are 26 nationalities represented with others on the way.

Wade Park and the Fine Arts Gardens are adjacent to the CMA. They sit on land that was donated to the city by Western Union Telegraph Company founder, Jeptha H. Wade. Wade Oval has just finished a $1.4 million renovation project. More lighting, benches, and pathways were added for visitors to enjoy the parks. The park also features fiber-optic technology that offers people the use of their laptops while at the park.

Lake View Cemetery is in this chapter because of its beauty and landscaping. It is a place for quiet reflection, but it is also a place to learn about the history and flora of the Western Reserve. Lake View Cemetery is literally a who's who of Cleveland. Its 285 acres feature architecture, geology, sculpture, animal life, and horticulture. It is no wonder that it is called "Cleveland's outdoor museum and arboretum." Some famous people who are buried in the cemetery are John D. Rockefeller, Jeptha H. Wade, Samuel and William Mather, and Pres. James A. Garfield.

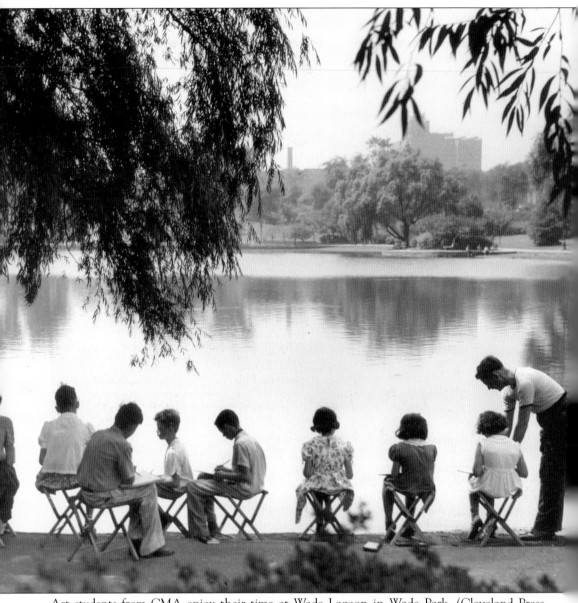

Art students from CMA enjoy their time at Wade Lagoon in Wade Park. (Cleveland Press Collection, CSU.)

Elizabeth Ring Ireland Mather (1891–1957) was the wife of Cleveland industrialist William G. Mather. She founded the Garden Center of Greater Cleveland, which became Cleveland Botanical Garden. She gave money to start the Ireland Cancer Center at University Hospitals, University Circle Development Foundation, and a vegetable relief garden project that benefited 40,000 people during the Great Depression. (Cleveland Press Collection, CSU.)

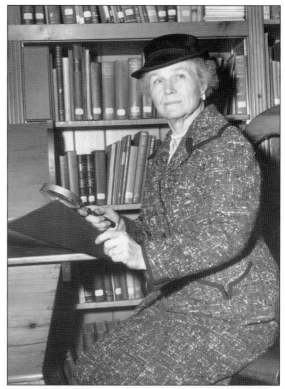

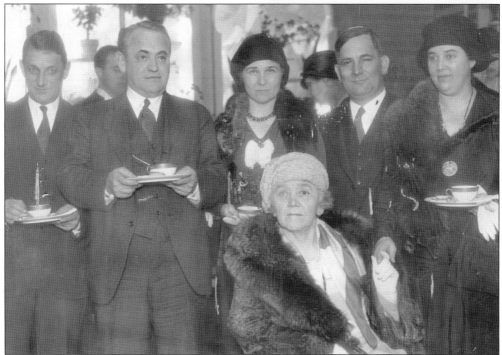

Pictured here are Elizabeth Mather and Mayor John Marshall (second from left) at the 1930 founding of the Garden Center of Greater Cleveland. (Cleveland Press Collection, CSU.)

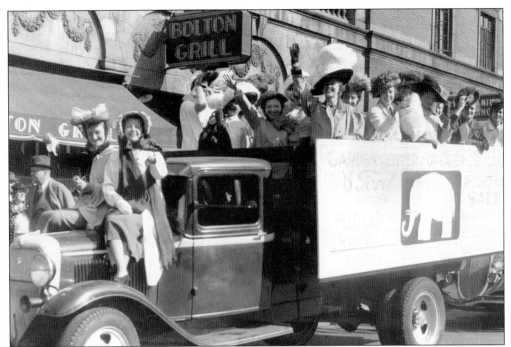

What a way to raise money—a bunch of pretty women on a truck. This is the 1934 White Elephant Sale, which would be a tradition for raising money for the garden. (Cleveland Press Collection, CSU.)

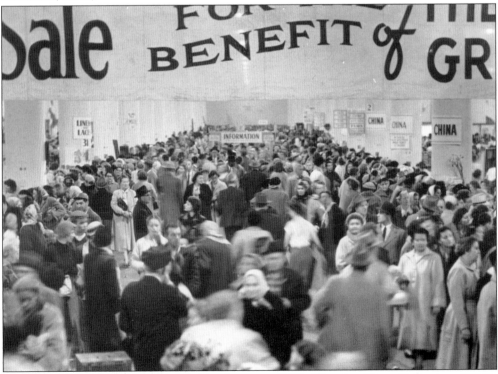

The sale always brought in big crowds like this one in 1957. (Cleveland Press Collection, CSU.)

Visitors study the tree exhibit at Cleveland Botanical Garden in 1971. (Cleveland Press Collection, CSU.)

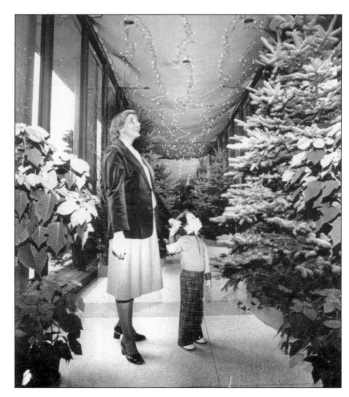

The Christmas Show is an annual event hosted by the Cleveland Botanical Garden. Currently it offers an exhibit of gingerbread houses during the Christmas season. (Cleveland Press Collection, CSU.)

This is the Garden Center of Greater Cleveland's original 1939 building. (Cleveland Press Collection, CSU.)

In 1882, this carriage house was used by Jeptha H. Wade to house his horses. The garden center used it as a storage shed. (Cleveland Press Collection, CSU.)

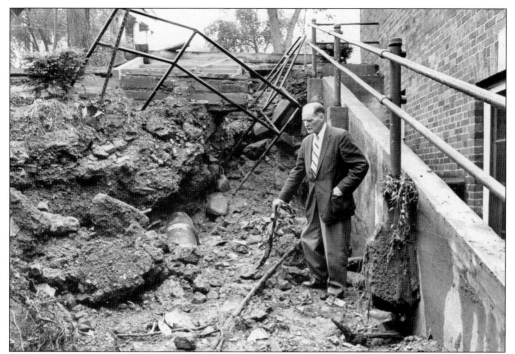

James Pritchard, president of the Garden Center of Greater Cleveland, looks over the damage by a flood in 1962 that caused the botanical garden to move to its current location. (Cleveland Press Collection, CSU.)

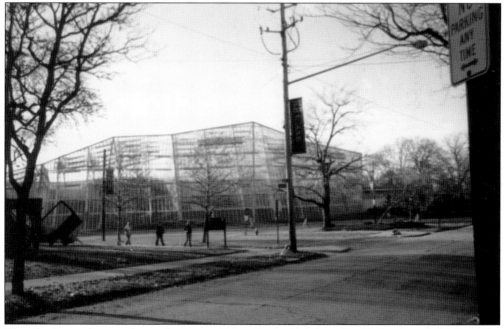

The glasshouse houses the garden's two distinctive ecosystems, the Madagascar desert and the Costa Rican cloud forest. Part of the cloud forest exhibit included a walk through more than 200 butterflies and a waterfall. (Photograph by the author.)

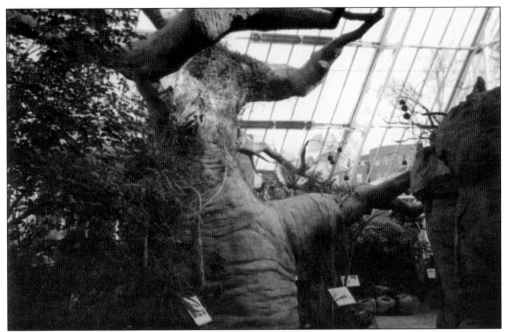

This is the great cloud forest tree, which is a 50-foot replica of a straight fig. There is a walkway above the cloud forest to allow visitors a bird's-eye view of the forest floor. (Photograph by the author.)

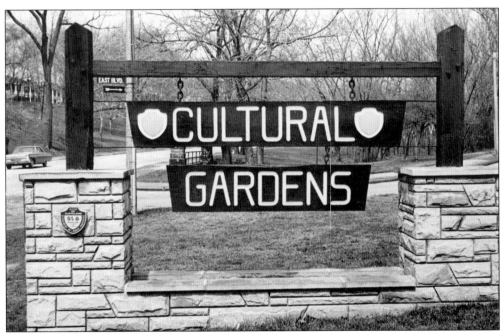

This is the sign one sees when entering the Cleveland Cultural Gardens inside Rockefeller Park along Martin Luther King Jr. Drive. The Cleveland Cultural Gardens sit on land that was donated to the city by John D. Rockefeller for the country's birthday in 1876. (Cleveland Press Collection, CSU.)

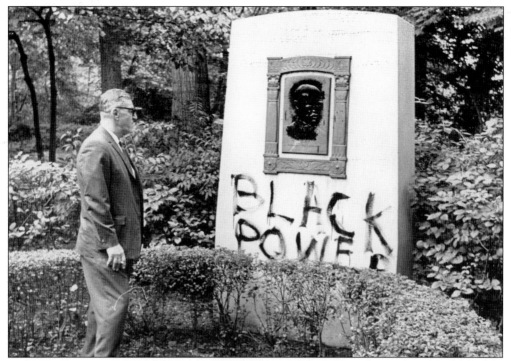

The Cleveland Cultural Gardens were not immune to the civil unrest of the 1960s and 1970s. (Cleveland Press Collection, CSU.)

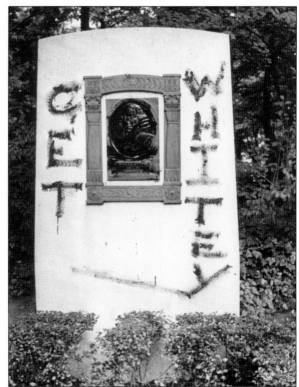

Between July 18 and July 24, 1966, a series of riots known as the Hough Riots broke out. They were sparked by racial tensions that had existed for years in the city. In the end, four people were killed, 30 were wounded, 300 were arrested, and 240 fires were reported. (Cleveland Press Collection, CSU.)

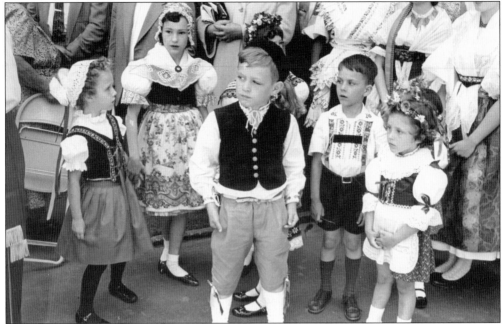

Children dress in their native Czech clothing. Currently there are 37,000 Clevelanders who have Czech heritage. Czechs came to Cleveland in large numbers from 1870 to the outbreak of World War I. They were escaping persecution by their Austro-Hungarian overlords. (Cleveland Press Collection, CSU.)

This 1939 parade celebrated the Russian Garden in the Cleveland Cultural Gardens. Cleveland never had a very large Russian population. Most came to Cleveland either before the 1917 Russian Revolution or in the 1990s after the collapse of the Soviet Union. (Cleveland Press Collection, CSU.)

This is the 1939 groundbreaking of the Irish Garden. The garden is shaped like a Celtic cross. One of the largest ethnicities in Cleveland, nearly 100,000 Clevelanders have Irish ancestors. (Cleveland Press Collection, CSU.)

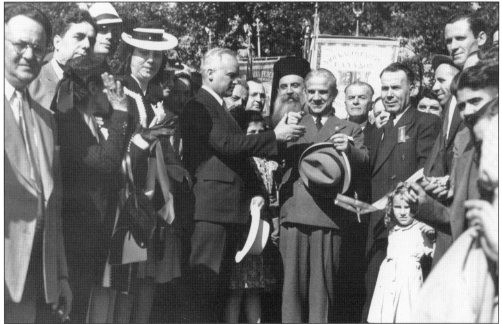

Pictured here is the Greek Garden attended by Minister Cimon P. Diamantopoulos in 1940. Some 15,000 Clevelanders have Greek heritage. The center of the social and cultural society is the Greek Orthodox Church, which hosts several festivals during the year. (Cleveland Press Collection, CSU.)

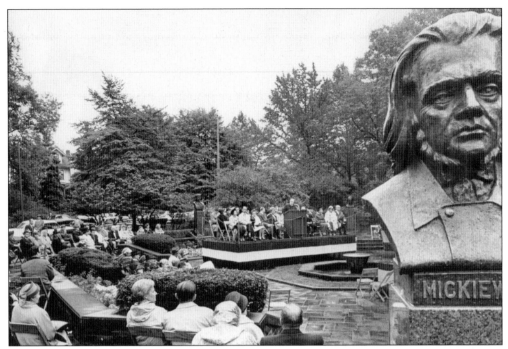

Pictured here is the dedication of Polish poet Adam Miczkiewicz in 1966. The Poles make up one of the largest ethnicities in Cleveland. They settled in the area known as Slavic Village and produced two Polish newspapers. (Cleveland Press Collection, CSU.)

Polish veterans of World War I place a wreath at their nationality's garden in Cleveland in 1930. In nine years, Poland would again be at the center of another world war. (Cleveland Press Collection, CSU.)

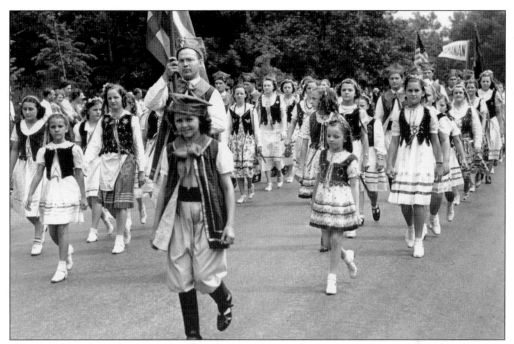

Polish children parade in their national costumes to celebrate their garden and their heritage on August 1, 1939. One month later, their country would be attacked by Nazi Germany, igniting World War II. (Cleveland Press Collection, CSU.)

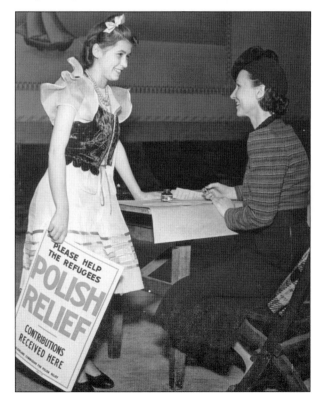

Volunteers in Cleveland discuss how to help Poland and its people during Easter of 1940. (Cleveland Press Collection, CSU.)

Work is begun on the Italian Garden in 1930. When dedicated, 5,000 Italian Americans were in attendance. (Cleveland Press Collection, CSU.)

A worker places a column that will be used for the bust of Virgil. Virgil (70 BC–19 BC) was a Roman poet whose work is a major influence on literature. (Cleveland Press Collection, CSU.)

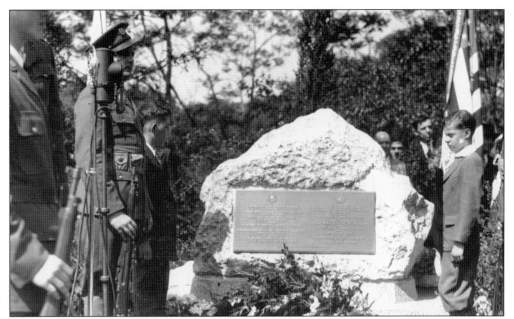

This rock is from Monte Grappa in Italy. When World War II broke out, Cleveland's Italians were very divided, with family members fighting on both sides. Pvt. Frank Petrarca was mortally wounded on his 25th birthday trying to rescue a wounded comrade in the Solomon Islands. Petrarca died of his wounds and was the first Ohioan in the war to be awarded the Congressional Medal of Honor. (Cleveland Press Collection, CSU.)

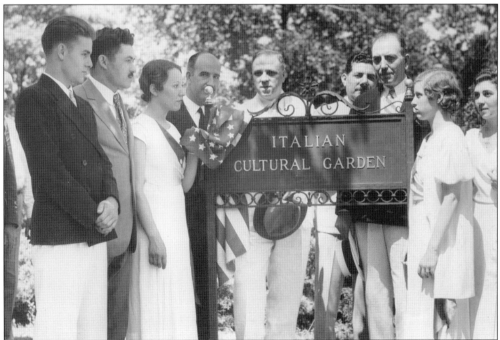

The Italian immigrants who came to Cleveland excelled in many businesses. They were in produce and groceries, monument and stone work, and in the restaurant industry. Much of their work can still be seen and enjoyed today. (Cleveland Press Collection, CSU.)

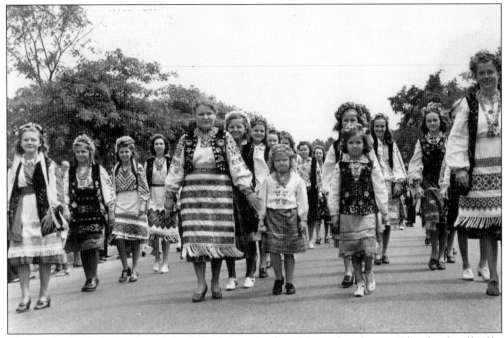

This is the 1940 dedication of the Ukrainian Garden. Many churches in Cleveland still offer masses in Ukrainian. (Cleveland Press Collection, CSU.)

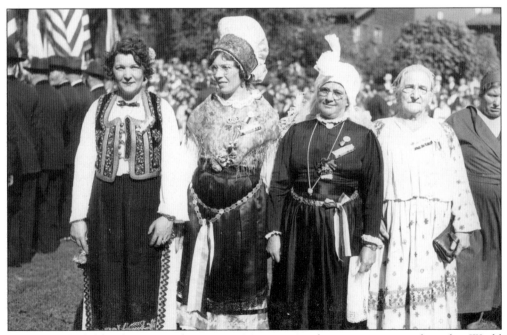

These four look like they are ready to party. Many nationalities were put together after World War I by the Allies to form Yugoslavia, including Slovenia, Serbia, Croatia, and Bosnia. In 1991, Slovenia declared its independence and fought a 10-day war with Yugoslavia. Eighteen Slovenians were killed, but Slovenia won its independence. (Cleveland Press Collection, CSU.)

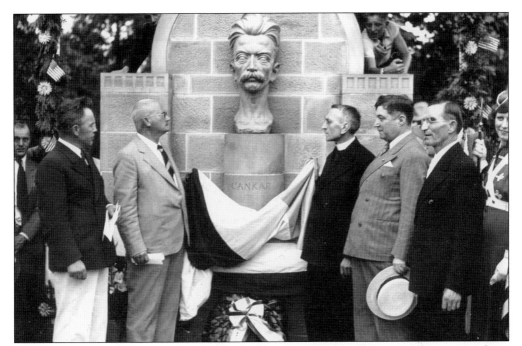

This is the Slovenian poet Ivan Gankar at the Slovenian Garden. Slovenes make up a very large proportion of Cleveland's population. In fact, more Slovenes live in Cleveland than any other city in the United States. (Cleveland Press Collection, CSU.)

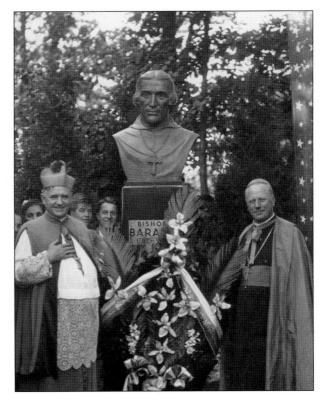

This is the statue of Slovenian Bishop Frederic Baraga (1797–1868). The bishop was known as the "snowshoe priest" for his missionary work with Native Americans of the Great Lakes region. Baraga learned to speak and write in every native language. (Cleveland Press Collection, CSU.)

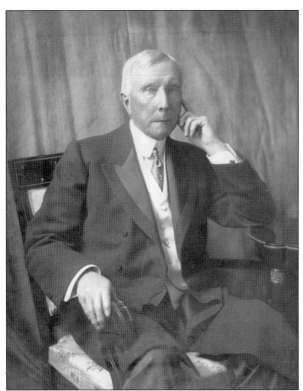

Pictured here is Standard Oil Company founder and richest man in America, John D. Rockefeller. He gave the city donations of land and money for the centennial birthday in 1876. Rockefeller ended up leaving Cleveland for New York City over taxes. (Cleveland Press Collection, CSU.)

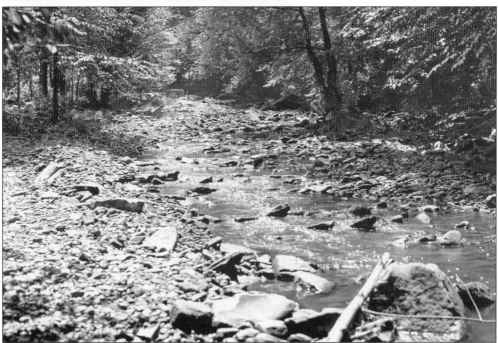

This is a view of Doan Brook, named for the family that first settled the University Circle area. This shot was taken before the retaining walls were built to help control flooding. (Cleveland Press Collection, CSU.)

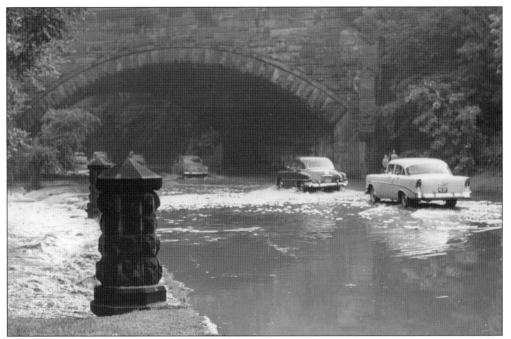

A flood in 1956 caused the city to build retaining walls. This view shows one of the Rockefeller bridges, a series of intricate stone bridges over the valley that Rockefeller gave the city the money to construct and maintain. (Cleveland Press Collection, CSU.)

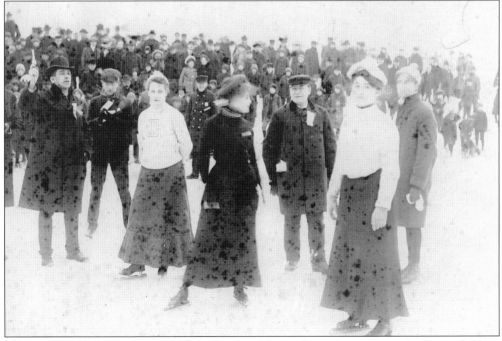

This was a 1900 skating party on Wade Lagoon. This is the same water that the Doan children used to skate on. In 1900, there was ice-skating on real ice; currently it is possible to skate on polymer rinks with no ice at all. (Cleveland Press Collection, CSU.)

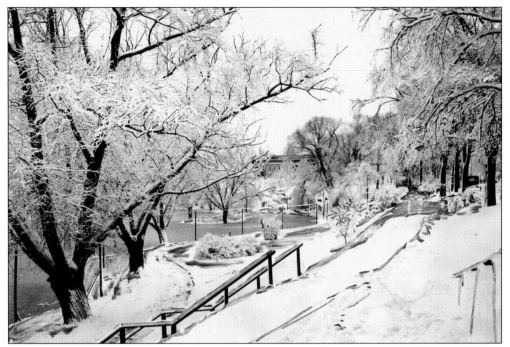

Clevelanders love that their city has four distinct seasons. Winter is a beautiful time of year in Wade Park. Winter is great except for the snow, cold, and gray skies. (Cleveland Press Collection, CSU.)

A small crowd attended the launching of this new ship into Wade Lagoon. (Cleveland Press Collection, CSU.)

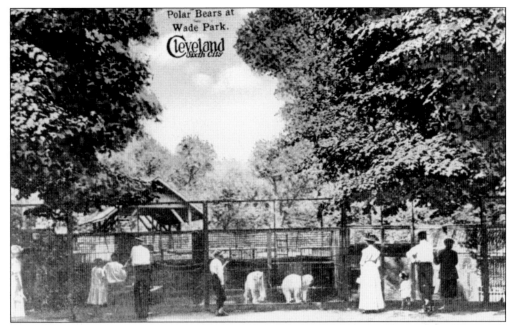

The Wade Park Zoo, predecessor of Cleveland Metroparks Zoo, was located in University Circle. The zoo began with a small group of deer placed there in the 1880s. (Cleveland Press Collection, CSU.)

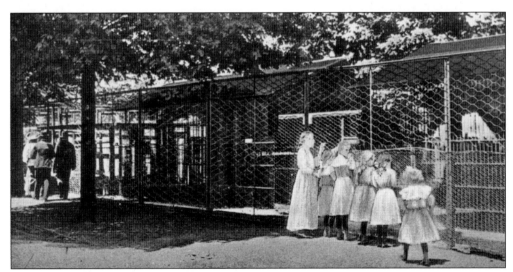

Wade Park Zoo lasted until the opening of the Cleveland Museum of Art in 1916. Wade Park Zoo moved to its new home at Cleveland Metroparks Zoo in 1916. Gradually the animals were moved to its Brookside Reservation location that it now occupies. Today Cleveland Metroparks Zoo occupies 168 acres and has some 3,300 animals. (Cleveland Press Collection, CSU.)

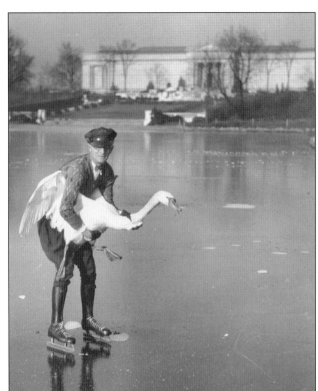

This is what happens in Cleveland when birds do not fly south for the winter. The next year, this swan started flying south in September. (Cleveland Press Collection, CSU.)

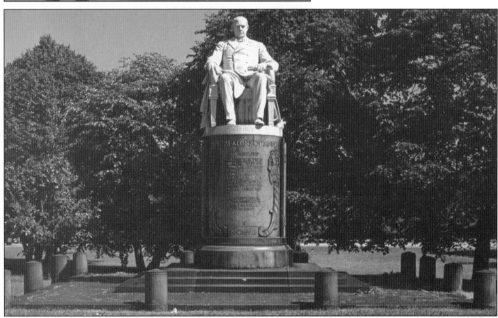

Pictured here is a statue of Mark Hanna (1837–1904), the "king maker." Hanna was the Republican national leader and helped elect Ohio governor William McKinley to two successful presidential campaigns. Hanna was instrumental in putting Teddy Roosevelt on the 1900 ticket to "get rid of him." Little did anyone expect, Roosevelt would assume the presidency on McKinley's assassination in 1901. (Cleveland Press Collection, CSU.)

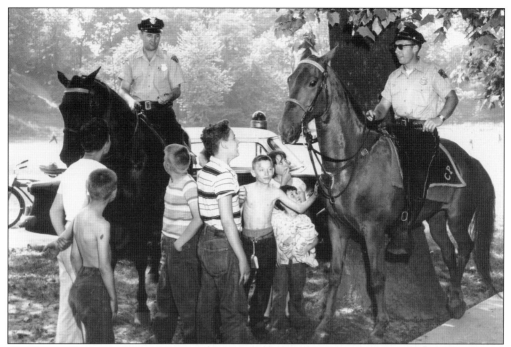

Children talk to two Cleveland Mounted Police in 1956. Cleveland's mounted unit dates from the early 1900s and was one of the longest continuously operating units in the United States. (Cleveland Press Collection, CSU.)

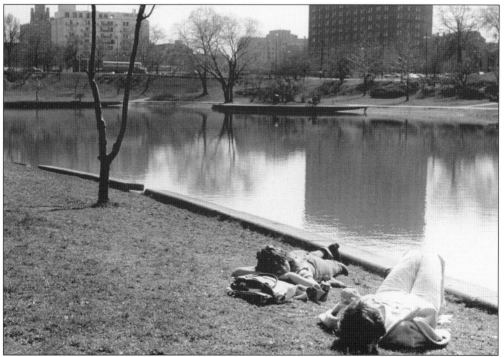

Two students relax next to Wade Lagoon. As one can imagine, Wade Park is a popular spot for hard-working students in University Circle. (Cleveland Press Collection, CSU.)

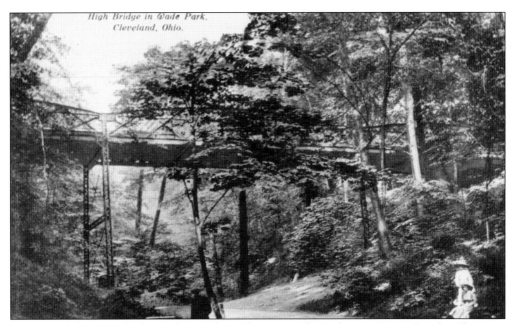

This 1900 photograph shows the High Bridge in Wade Park over Doan Brook. This area of University Circle is surprisingly hilly and full of creeks and valleys. (Cleveland Press Collection, CSU.)

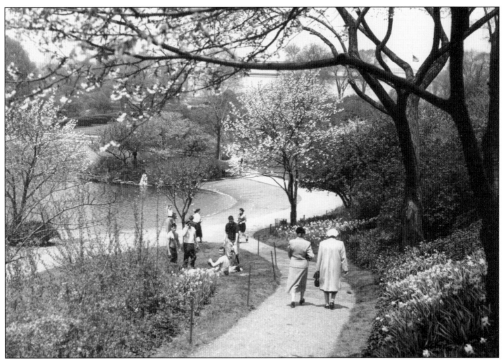

Clevelanders enjoy a stroll on a beautiful spring day in Wade Park. Nothing cures cabin fever like a walk on a warm day in University Circle. (Cleveland Press Collection, CSU.)

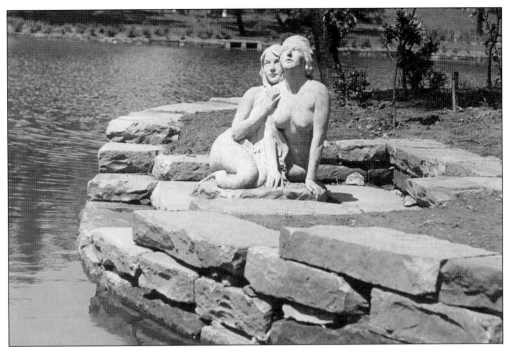

There are all sorts of interesting sights in Wade Park to look at. This is a sculpture from the Fine Arts Garden. Brothers Frederick Law Olmsted Jr. and John Charles Olmsted, designers of New York City's Central Park, planned the garden in 1927. (Cleveland Press Collection, CSU.)

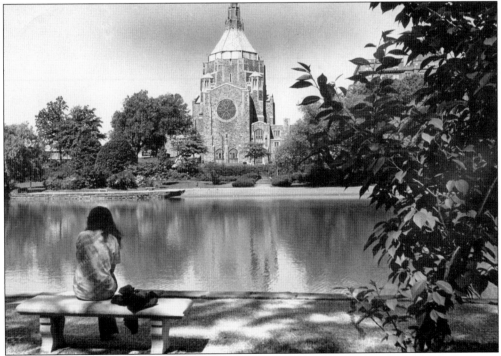

The "Holy Oil Can," or Epworth-Euclid United Methodist Church, overlooks Wade Park and Lagoon. It was built in 1928 and is 200 feet tall. (Cleveland Press Collection, CSU.)

Lake View Cemetery was founded in 1869 with the purchase of 200 acres at a cost of $73,000. Its first president was Jeptha H. Wade. This picture shows workers constructing a dam. (Cleveland Press Collection, CSU.)

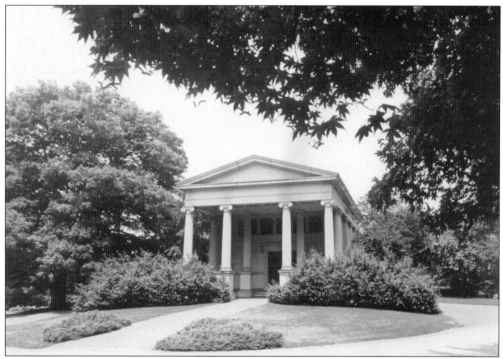

The Jeptha Wade Memorial Chapel was constructed in 1901 with a Tiffany-designed interior. (Cleveland Press Collection, CSU.)

One of the most famous residents of Lake View Cemetery is Pres. James A. Garfield. The president was shot on July 2, 1881, by Charles Guiteau, a disappointed office seeker. Alexander Graham Bell invented a metal detector to help locate the bullet in the president's chest, but the metal bed springs made the machine malfunction. Garfield hung on until September 19, 1881. The monument opened on Memorial Day in 1890. (Cleveland Press Collection, CSU.)

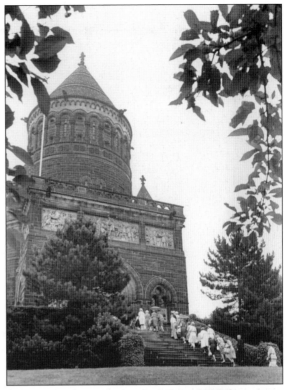

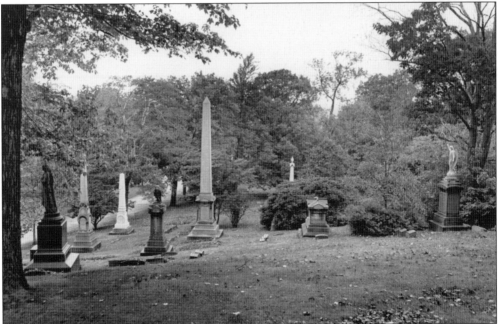

This beautiful view shows the rolling hills and landscaping of the cemetery. One of the most moving monuments is the memorial to the victims of the Collinwood School Fire in 1908. In all, 169 students and three adults died in one of Cleveland's most infamous disasters. (Cleveland Press Collection, CSU.)

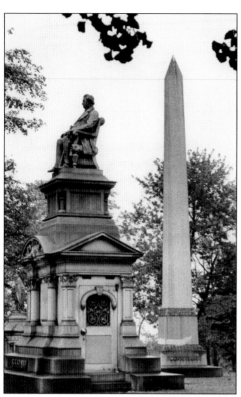

For the richest man in America, John D. Rockefeller's obelisk is very modest. Most of Cleveland's society is buried here. (Cleveland Press Collection, CSU.)

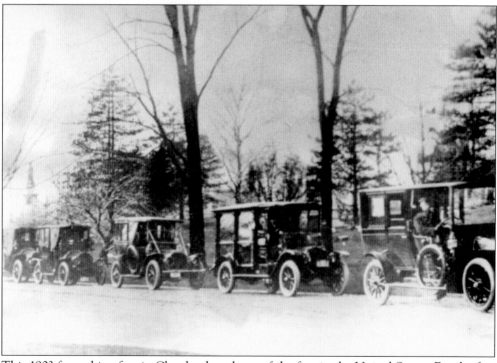

This 1903 funeral is a first in Cleveland, and one of the first in the United States. For the first time, the automobile has replaced the horse and carriage. (Cleveland Press Collection, CSU.)

Six

LITTLE ITALY AND SURROUNDING NEIGHBORHOODS

Little Italy is one of five major Italian neighborhoods that grew up in Cleveland. It was established in 1885 as a very close-knit community and had the reputation of being a closed community. Many of the Italian immigrants who lived in the area worked at the several marble works that were located nearby. In fact, much of the beautiful architecture of the University Circle area, especially Lake View Cemetery, can be traced to these immigrant workers.

In 1911, it was estimated that 96 percent of the inhabitants of Little Italy were Italian-born, and another two percent had Italian parents. Most of these inhabitants were Neapolitan and came from the towns of Ripamolisano, Madrice, and San Giovanni. Times have changed, even in Little Italy. In the city where the macaroni machine was invented in 1906, fewer than half of the 2,500 inhabitants are of Italian heritage.

Even so, Little Italy is one of Cleveland's most popular destinations. Rachel Ray, of the Food Network, made a point of stopping in Little Italy for some great food and shopping. Today visitors will find numerous restaurants, artist studios, shops, and historic architecture. The oldest restaurant in Little Italy is Guarino's, which opened in 1918.

The neighborhood in and around University Circle is so interesting. There are quaint cafés, bed-and-breakfasts, and interesting shops. At one block a person could be sipping a cappuccino, and the next, that person could be standing in front of an Underground Railroad site. Because of all the college students in the area, the neighborhood has a very young and exciting feeling to it. No matter what time of year one visits, the beauty and history of the region is amazing. University Circle is really Cleveland's jewel.

The Cozad-Bates House is an example of an Italianate–style residence. It is the only pre–Civil War structure remaining in University Circle. The house was built in 1853 and was a stop on the Underground Railroad. Over 40,000 slaves were transported over the Ohio Underground Railroad network. (Photograph by the author.)

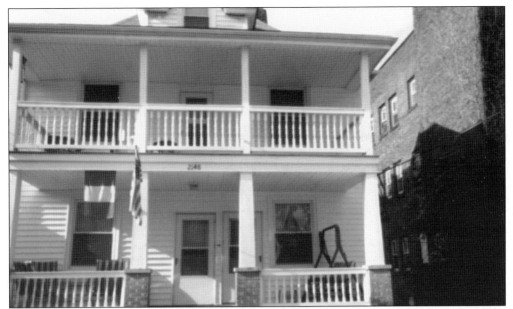

This is an example of a house in Little Italy. Notice how close the houses are to each other. Little Italy is a very small area with hills all around it, so space is at a premium. (Photograph by the author.)

This view looks up Mayfield Hill in Little Italy. There is a resurgence of people wanting to move to historic neighborhoods, and Little Italy is no exception. These are new town houses. (Photograph by the author.)

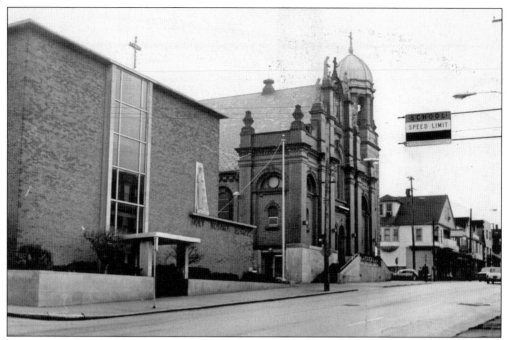

The center of any good Italian neighborhood is the Roman Catholic Church. This is Holy Rosary Church, which was built in 1892 to serve the blossoming Italian population of Cleveland. (Cleveland Press Collection, CSU.)

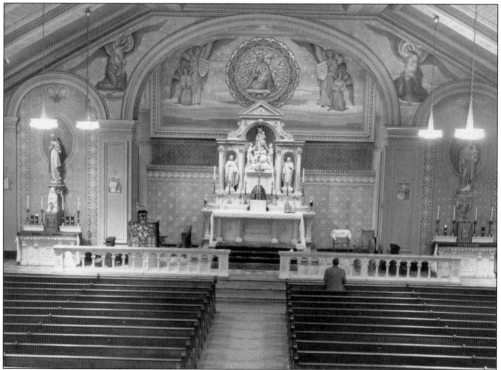

This is the interior of Holy Rosary Church. (Cleveland Press Collection, CSU.)

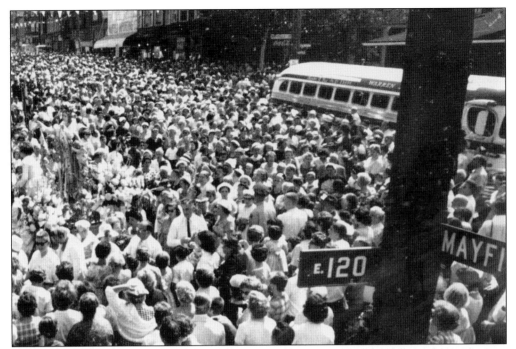

The annual Feast of the Assumption is held every year on August 15 to celebrate the assumption of the Virgin Mary into heaven. The feast is attended by thousands of people. (Cleveland Press Collection, CSU.)

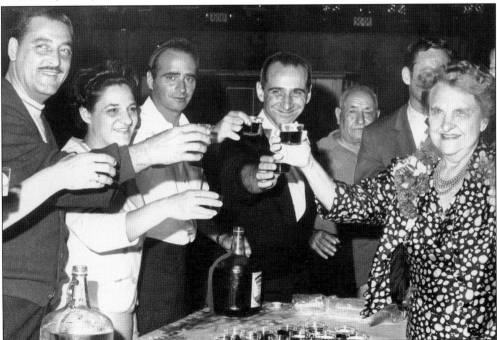

This was a wine tasting at the Gallucci Bar in 1968. Northern Ohio is actually a wonderful wine-making area because of the temperate climate caused by Lake Erie and the rich soil due to the glaciers. (Cleveland Press Collection, CSU.)

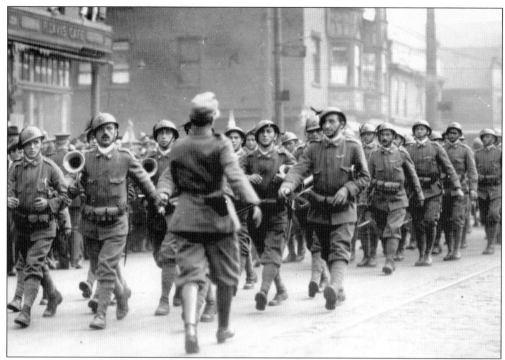

Pictured here are Italian Bersaglieri marching down Woodland Avenue. Each off these men was wounded during World War I. (Cleveland Press Collection, CSU.)

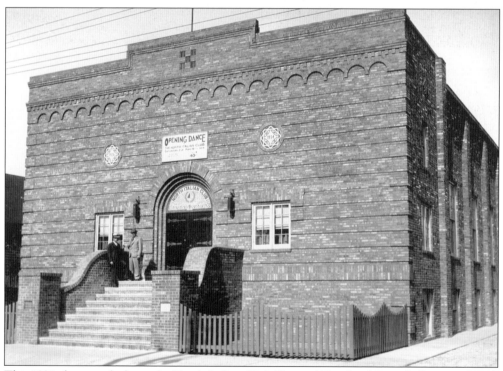

This 1934 photograph shows the North Italian Club House. (Cleveland Press Collection, CSU.)

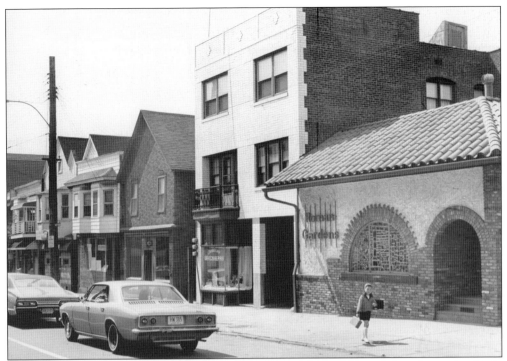

This is the Roman Garden Restorainte as it appeared in 1968. Not much has changed in Little Italy since those early days. (Cleveland Press Collection, CSU.)

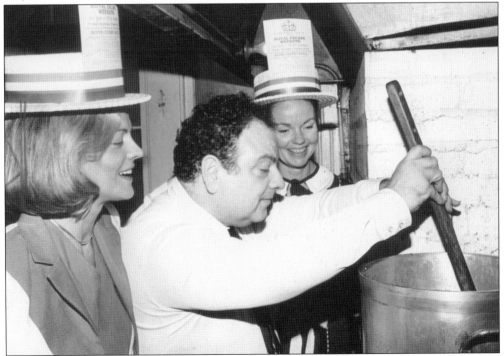

Bam! The secret is in the sauce. The oldest continually operating restaurant in Little Italy is Guarino's, which opened in 1918. (Cleveland Press Collection, CSU.)

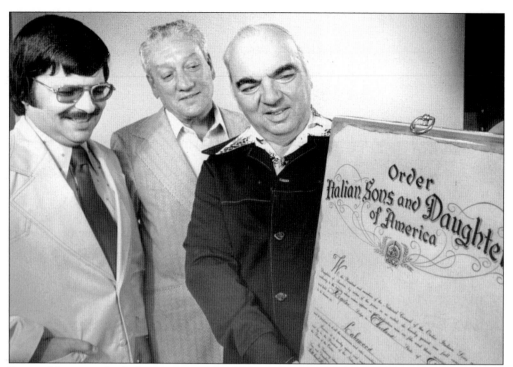

Pictured here are the Italian Sons and Daughters of America. Like many immigrant groups in America, the Italians formed close-knit communities. (Cleveland Press Collection, CSU.)

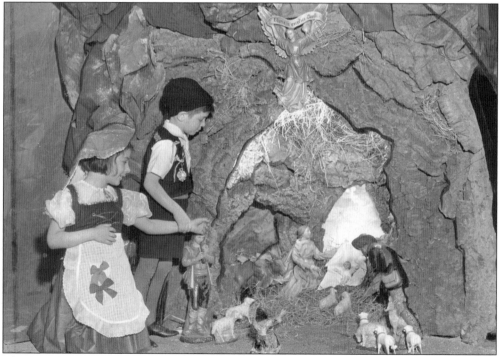

Children help decorate a nativity scene in Little Italy for Christmas. (Cleveland Press Collection, CSU.)

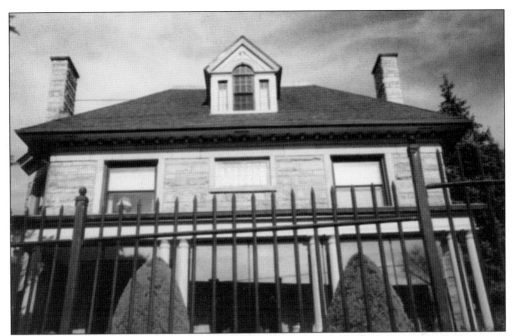

The Baricelli Inn, built in 1896, is a brownstone bed-and-breakfast in the heart of Little Italy. It offers seven spacious suites that provide the guests with a traditional European manner. (Photograph by the author.)

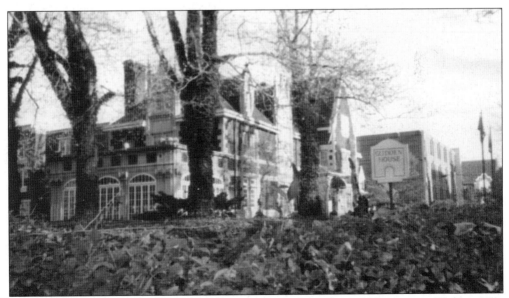

This home was owned by Glidden Paint Company founder, Francis Harrington Glidden. The house is now run as a bed-and-breakfast near the CWRU campus. It offers 52 rooms, eight suites, and banquet facilities. (Photograph by the author.)

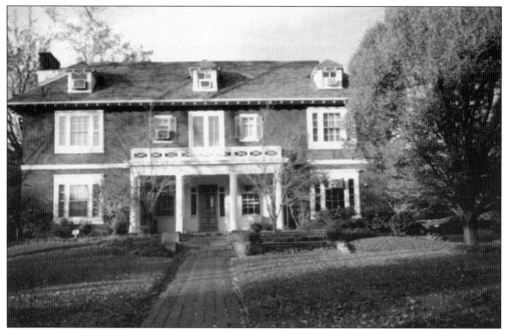

This is the headquarters of University Circle Inc. (UCI). UCI is the development, service, and advocacy organization responsible for the growth of University Circle as a premier urban destination. (Cleveland Press Collection, CSU.)

Follow the signs to University Circle. (Cleveland Press Collection, CSU.)

University Circle is the perfect place for a Sunday drive. (Cleveland Press Collection, CSU.)

It is also the perfect place for some quiet time together. (Cleveland Press Collection, CSU.)

ACROSS AMERICA, PEOPLE ARE DISCOVERING SOMETHING WONDERFUL. THEIR HERITAGE.

Arcadia Publishing is the leading local history publisher in the United States. With more than 3,000 titles in print and hundreds of new titles released every year, Arcadia has extensive specialized experience chronicling the history of communities and celebrating America's hidden stories, bringing to life the people, places, and events from the past. To discover the history of other communities across the nation, please visit:

www.arcadiapublishing.com

Customized search tools allow you to find regional history books about the town where you grew up, the cities where your friends and family live, the town where your parents met, or even that retirement spot you've been dreaming about.